DORSET IN PHOTOGRAPHS

MATTHEW PINNER

AMBERLEY

First published 2017

Amberley Publishing
The Hill, Stroud
Gloucestershire, GL5 4EP

www.amberley-books.com

Copyright © Matthew Pinner, 2017

The right of Matthew Pinner to be identified as the Author of this work has been
asserted in accordance with the Copyrights, Designs and Patents Act 1988.

ISBN 978 1 4456 7692 0 (print)
ISBN 978 1 4456 7693 7 (ebook)

British Library Cataloguing in Publication Data.
A catalogue record for this book is available from the British Library.

Origination by Amberley Publishing.
Printed in the UK.

ABOUT THE PHOTOGRAPHER

Matthew Pinner is a Dorset landscape photographer who is based within the town of Christchurch. He bought his first camera after his grandfather sadly passed away and left him his tripod in his will.

The main driving factor behind the making of this book has been the overwhelming support from Matthew's vast social following – 150,000 across all media platforms. He has achieved a fair bit of success already within his career, having provided many of his images to notable networks such as the BBC, ITV and major national newspapers. Leading companies within the photography world have also taken an interest in his work, supporting him through social media channels. Matthew uses a Canon 5D Mark 3, along with Canon lenses and Lee Filters.

Website: pinners-photography.co.uk
Facebook: Pinners Photography
Twitter: Matt_Pinner
Instagram: Matt_Pinner
Email: enquiriespinnersphotography.co.uk

ACKNOWLEDGEMENTS

I would like to thank several people that have helped me along the way, not only with this book but with my photography in general. Firstly, my fiancée Emma for sticking by me through all the early mornings to get that perfect sunrise, and all the late sunsets. It must be true love if you agreed to marry me after all I ask of you in aid of my career. Also, my family: my mum, dad, brother and sister, thank you for supporting me through all of the ups and downs I have faced within this industry. My long-term friend Dave, who took me out most days when I gained my interest in photography all those years ago. If it weren't for you, I wouldn't have discovered so many fantastic locations to photograph.

There has also been some amazing support from individuals that have been within the photography world for a while and I would love to give them praise for this achievement: Canon UK & Ireland, Angela Nicholson, Simon Parkin from *ITV Weather*, Helen Stiles from *Dorset Magazine*, Dorset Tourism, Caroline Sharp from Lulworth Estates, John Challis, Jade Grassby from *Bournemouth Echo*, Dean Murray from Cover Images, BBC Earth, Elliot Wagland, Paul Vass from BNPS, Rosie Barratt from *Amateur Photography Magazine*, and Robbie-Lee Valentine.

Lastly, I would like to thank all the photographers who have inspired me and kept me pushing the limits of my work:

Kevin Ferrioli (www.facebook.com/k.ferrioli)
Nick Lucas (www.facebook.com/nick.lucas.1614)
Martin Dolan (www.facebook.com/martindolanphotography)
Paul Dimarco (www.facebook.com/paul.dimarco.16)
Zoe Davis (www.facebook.com/zoedavisphotography1992)
Mark Bauer (www.facebook.com/MarkBauerPhotography)

INTRODUCTION

I first became interested in photography after I was given my first tripod; let's just say the rest is history. I live by the saying that you miss every shot you don't take. When I have a spare moment, I will be off researching the next place to capture with my camera, and when I'm free to explore I'm off roaming around Dorset and the Jurassic Coast.

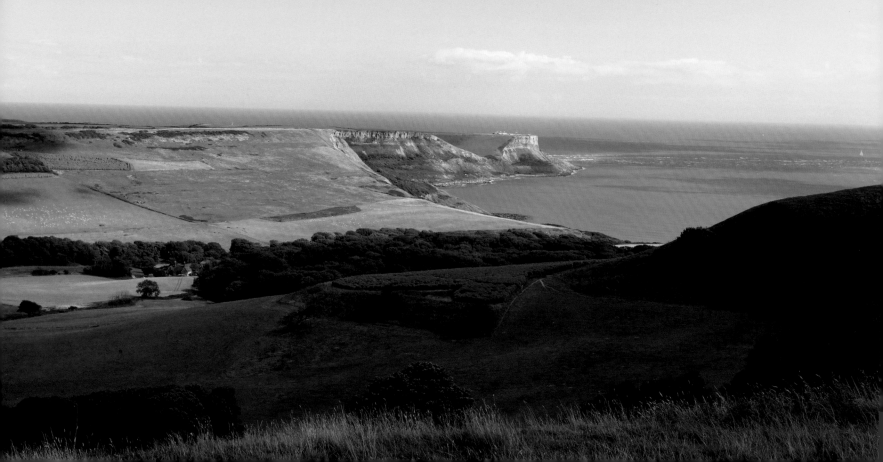

SPRING

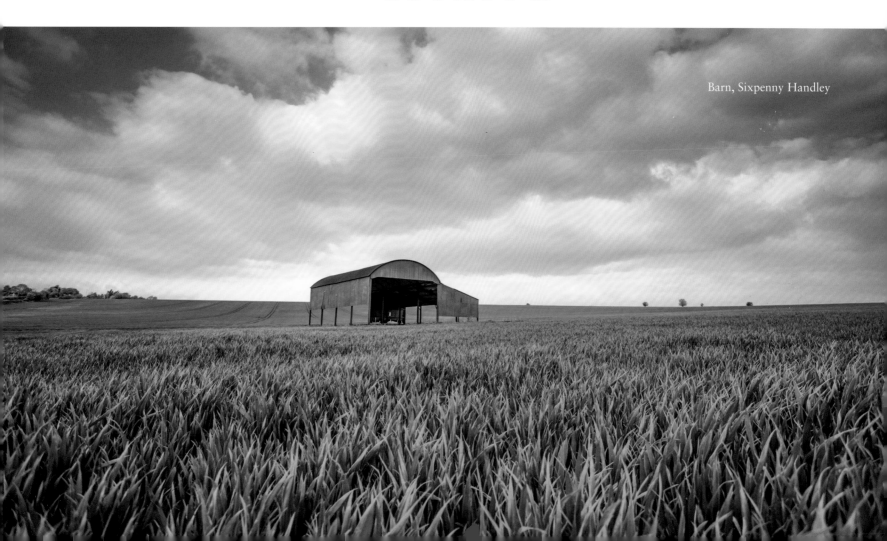

Barn, Sixpenny Handley

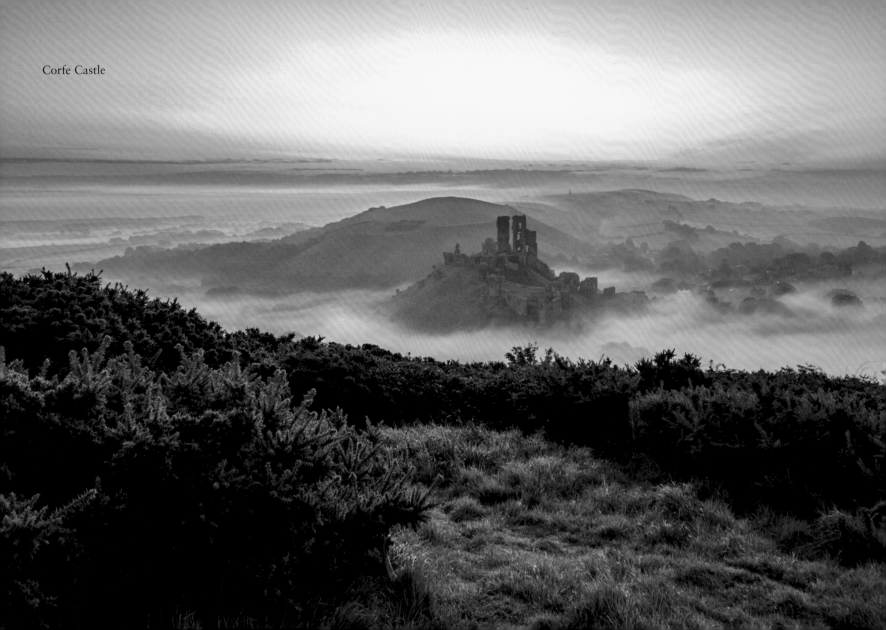

Corfe Castle

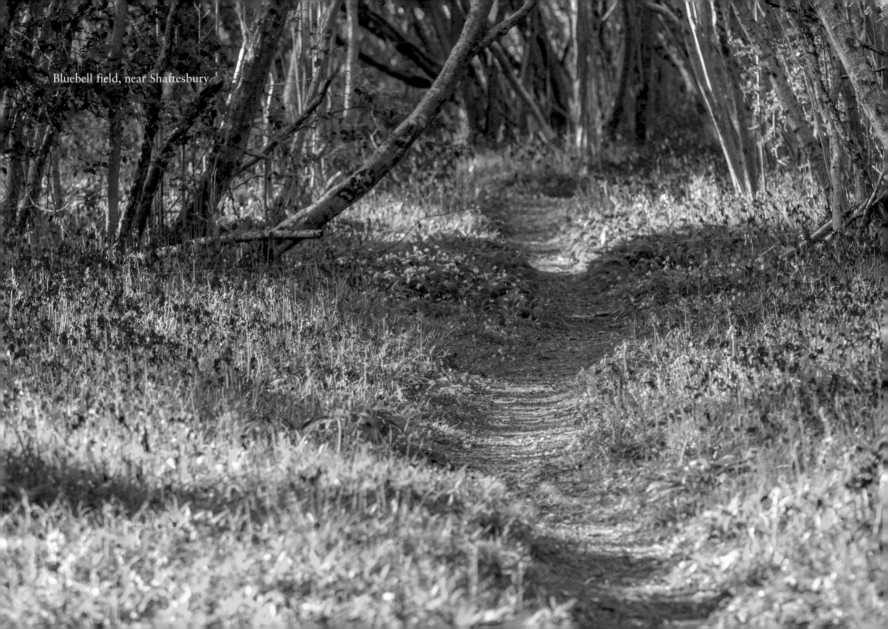
Bluebell field, near Shaftesbury

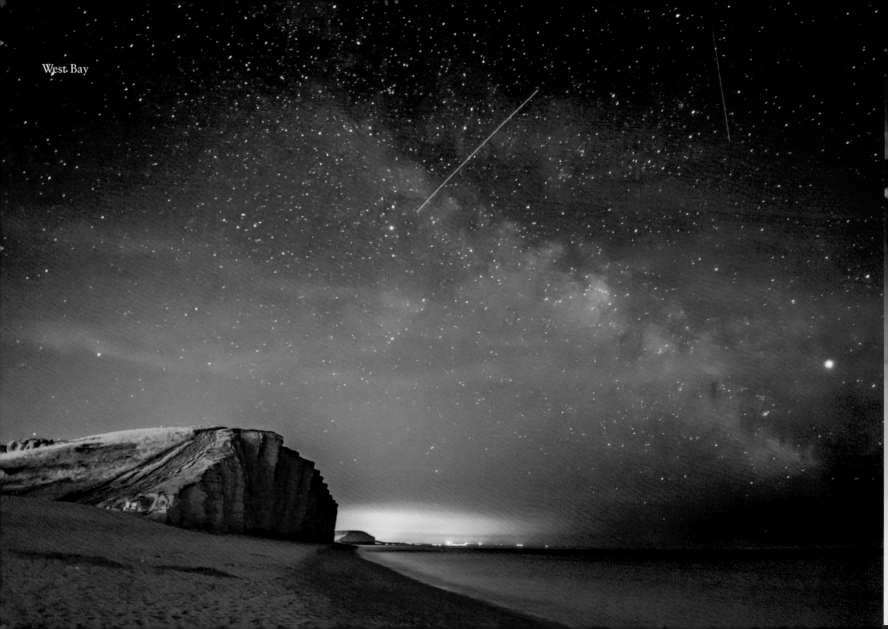

West Bay

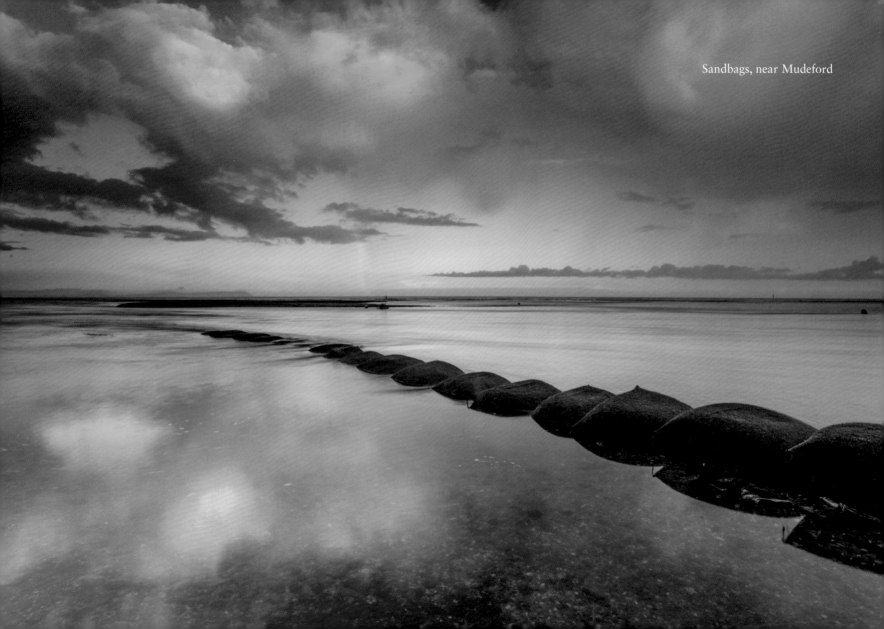

Sandbags, near Mudeford

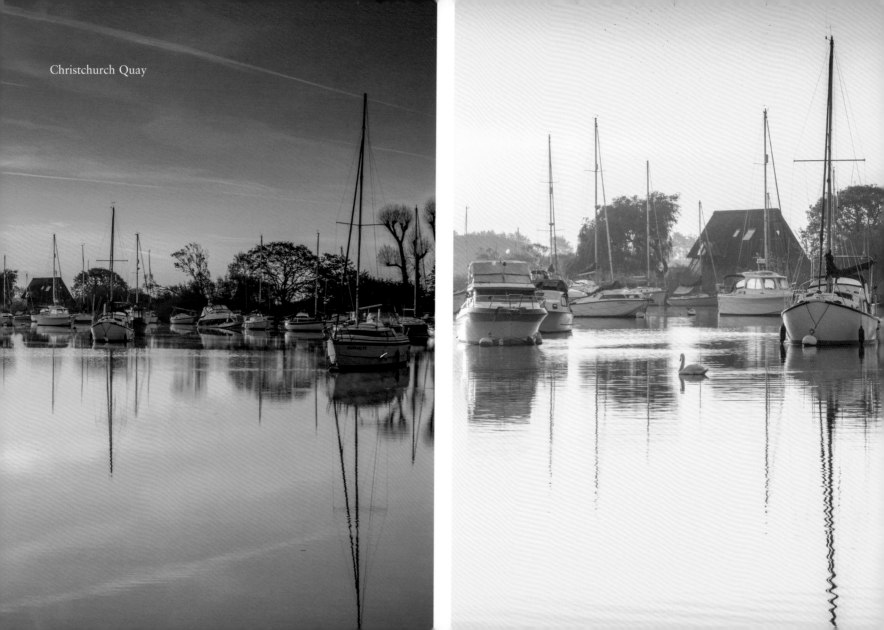

Christchurch Quay

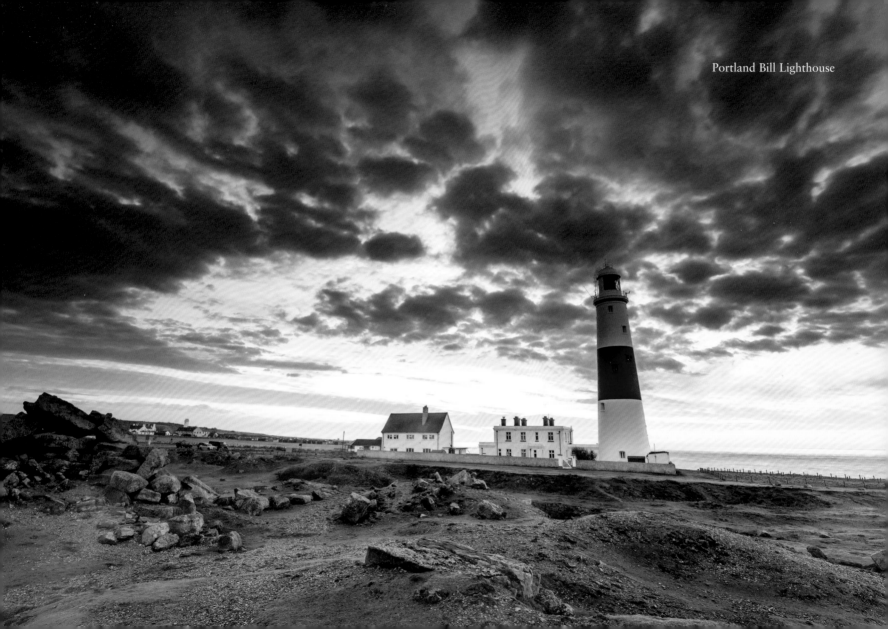

Portland Bill Lighthouse

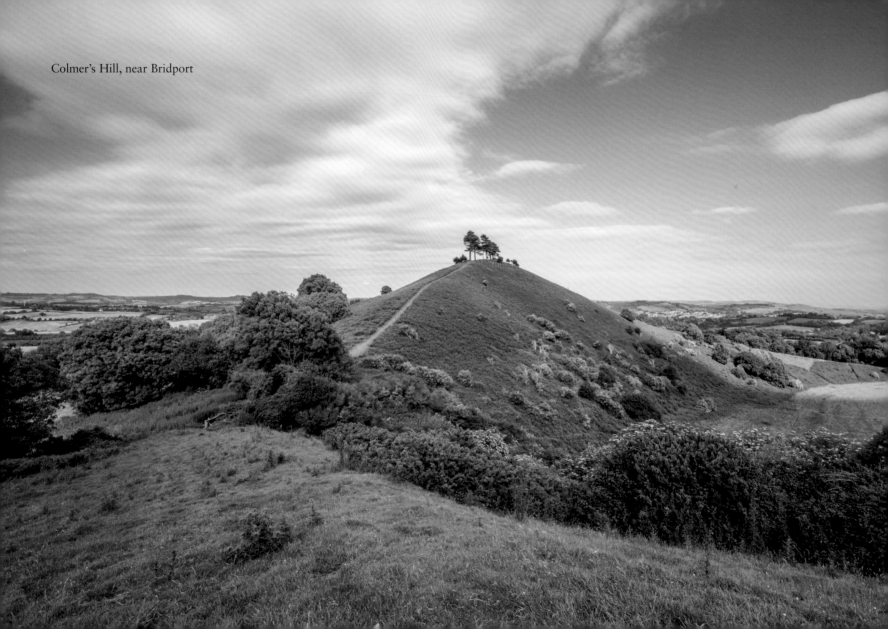

Colmer's Hill, near Bridport

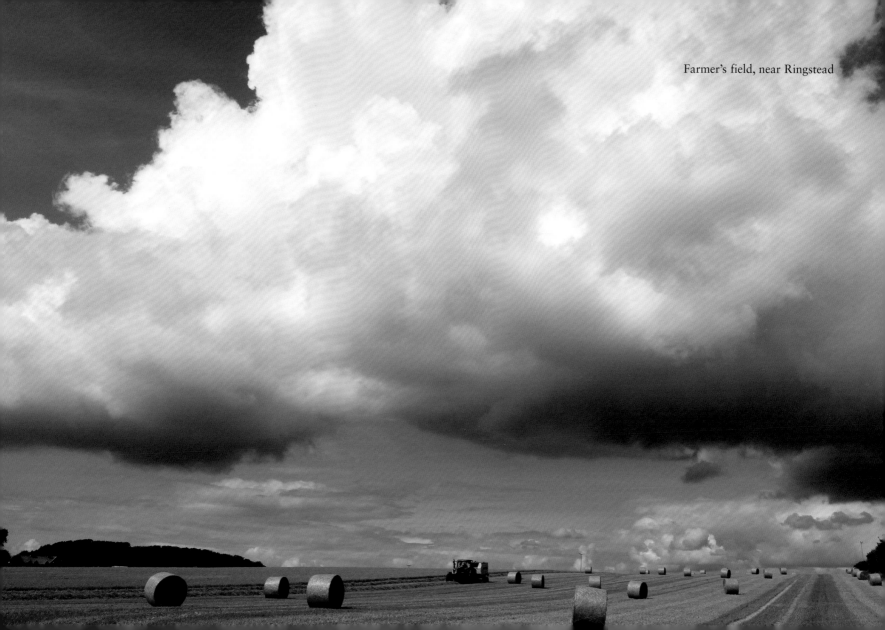

Farmer's field, near Ringstead

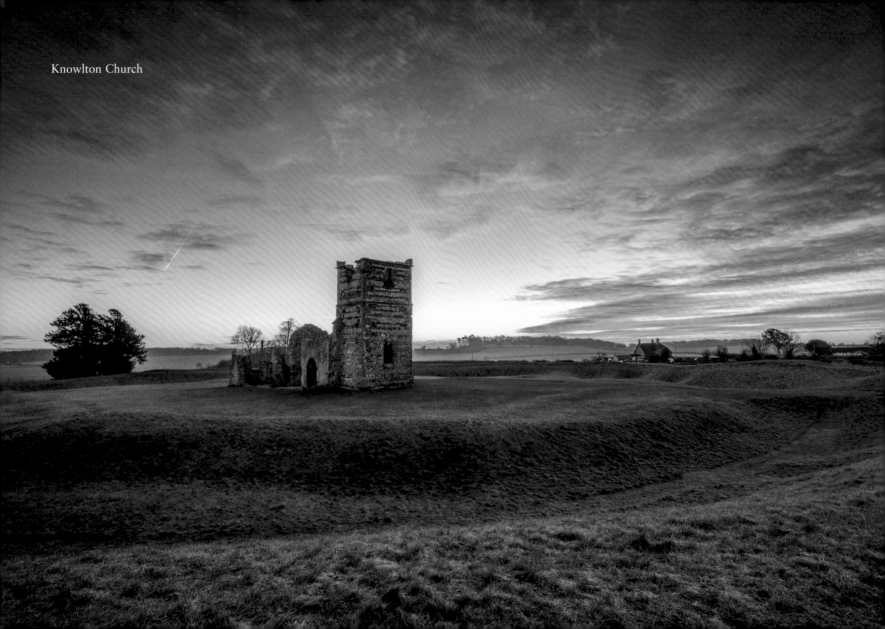

Knowlton Church

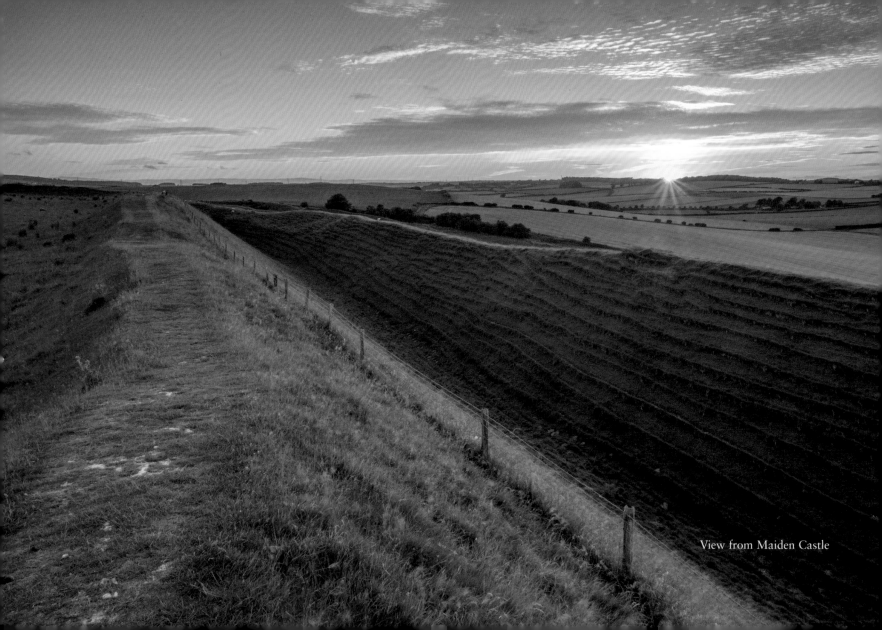

View from Maiden Castle

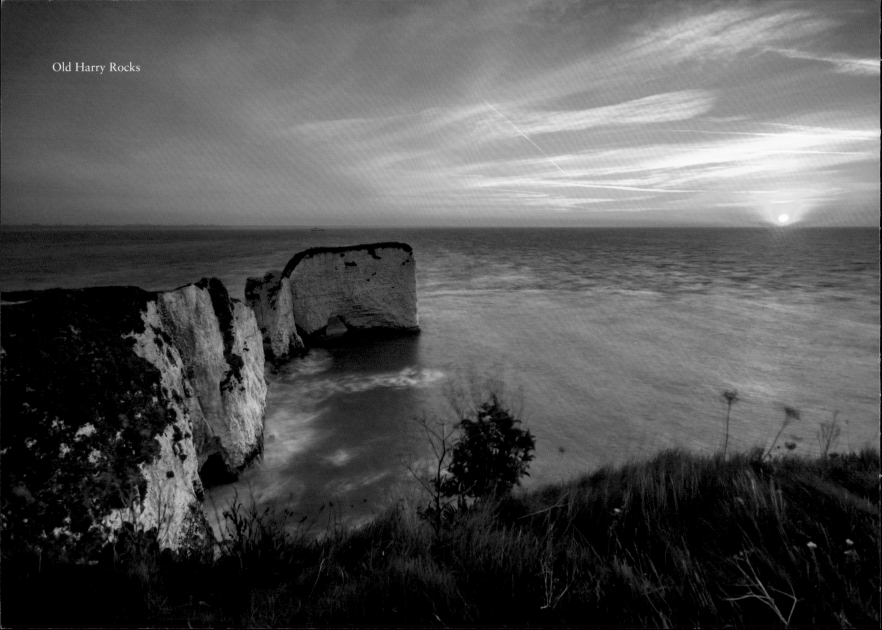

Old Harry Rocks

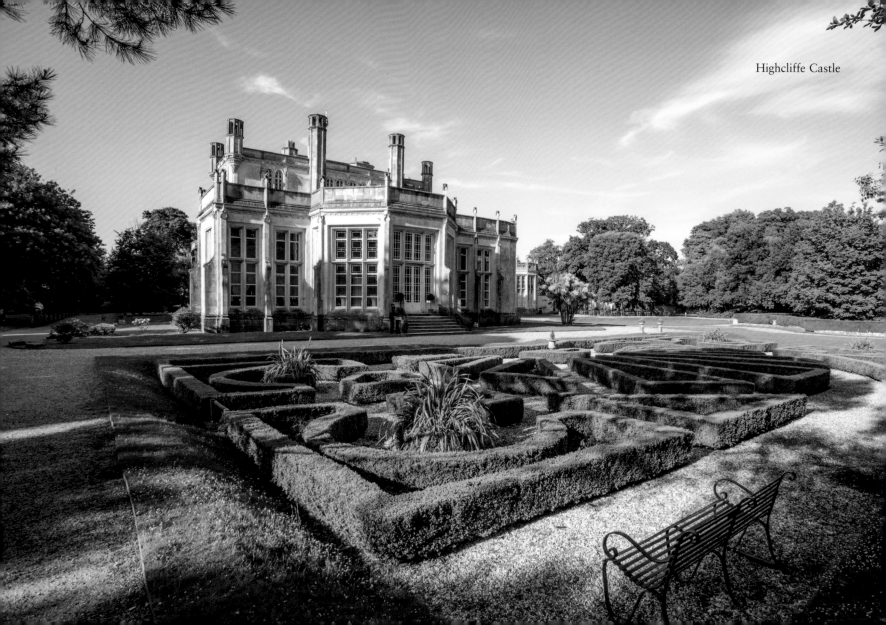
Highcliffe Castle

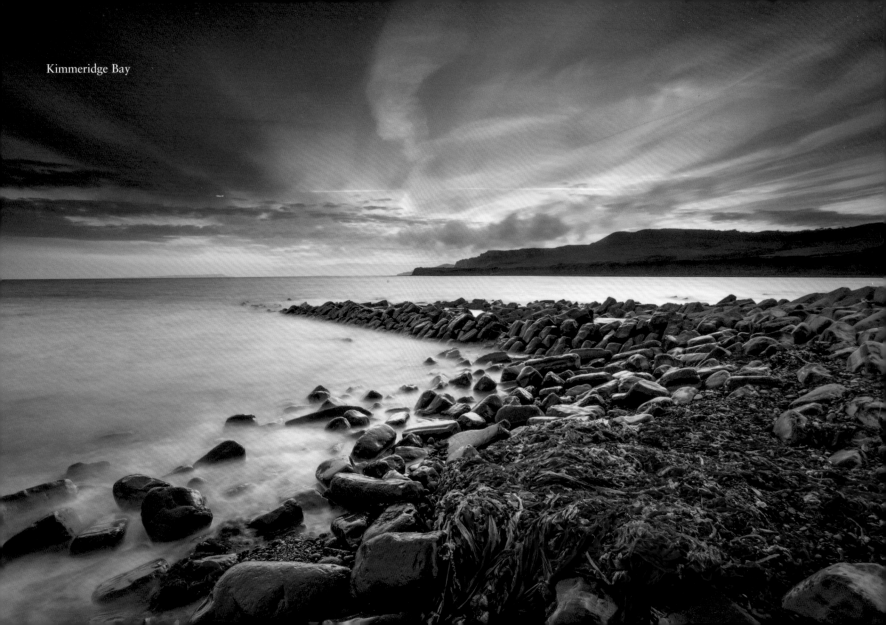

Kimmeridge Bay

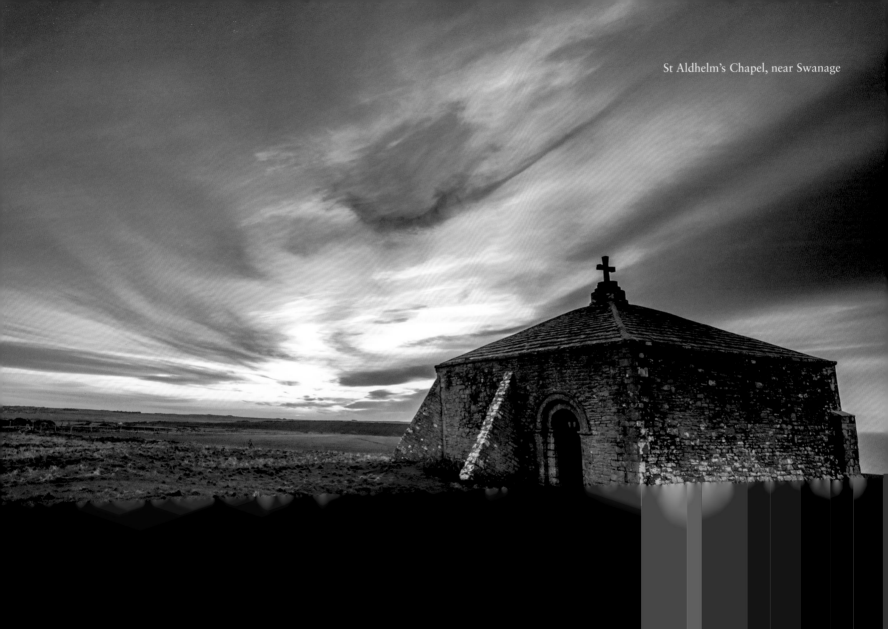
St Aldhelm's Chapel, near Swanage

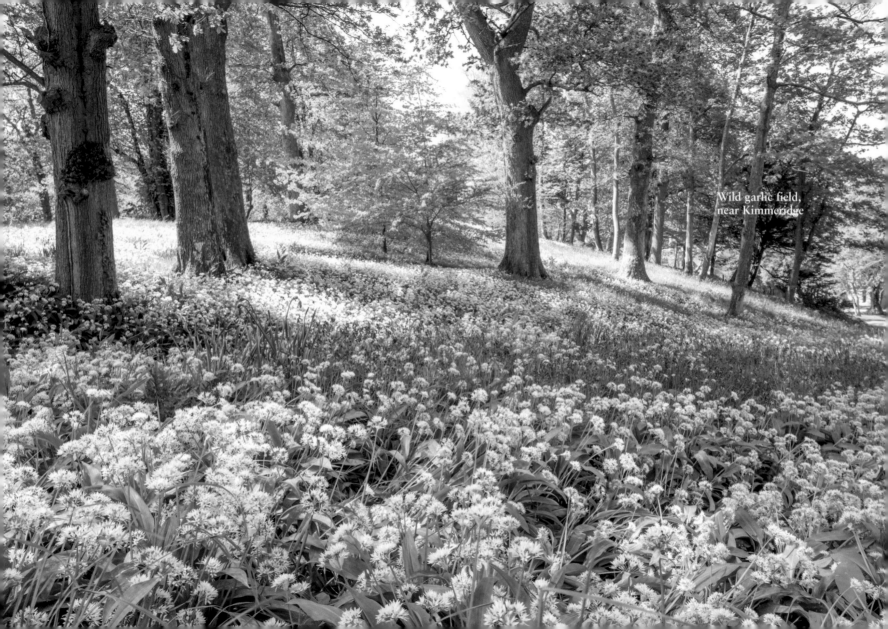
Wild garlic field,
near Kimmeridge

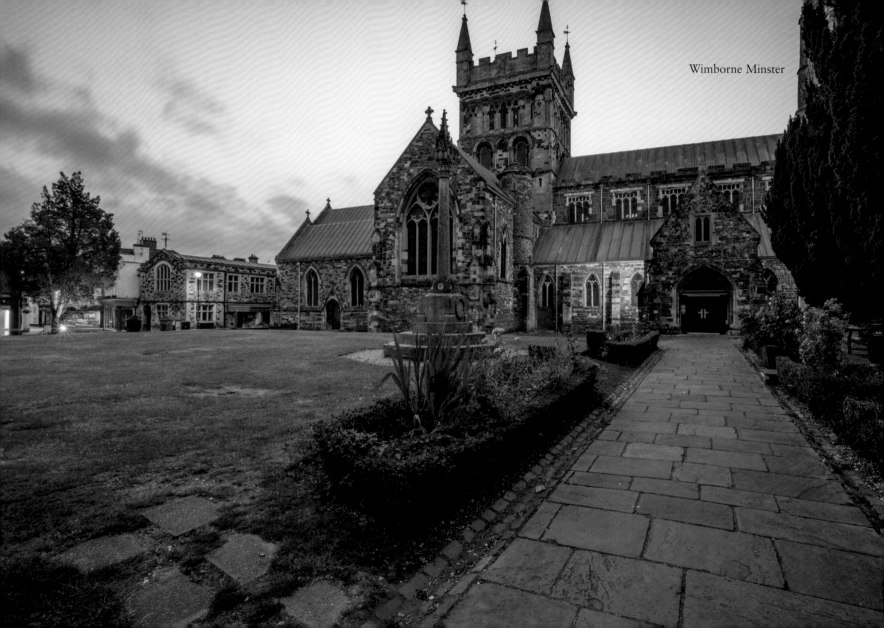

Wimborne Minster

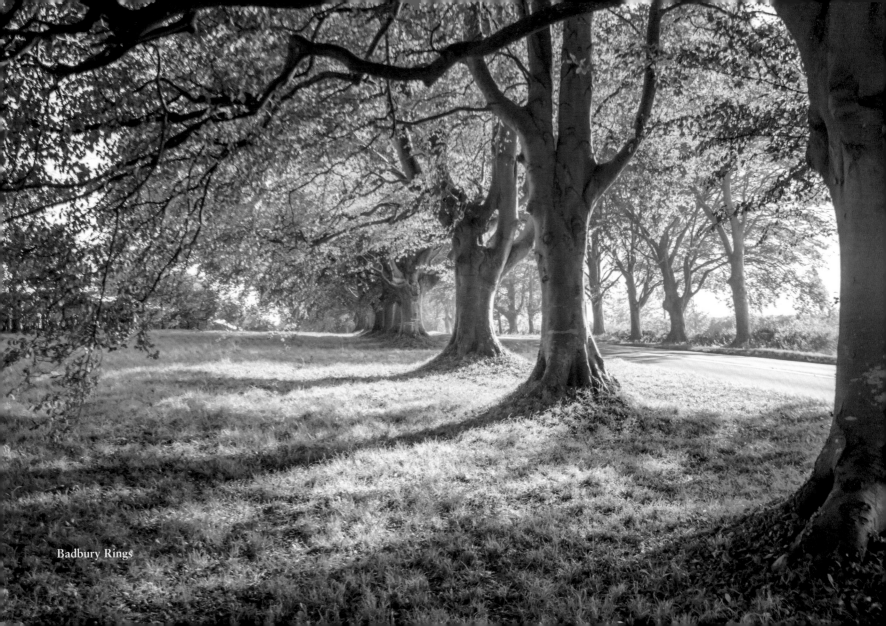

Badbury Rings

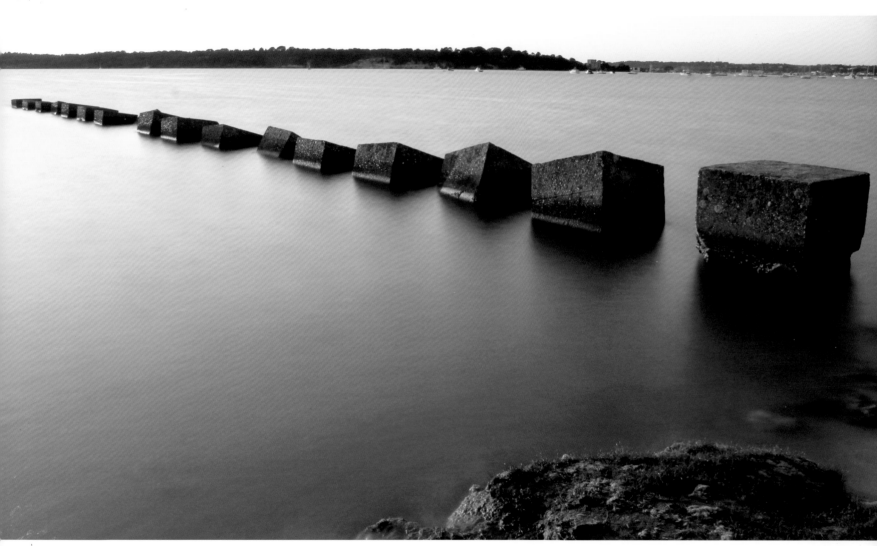

Sandbanks

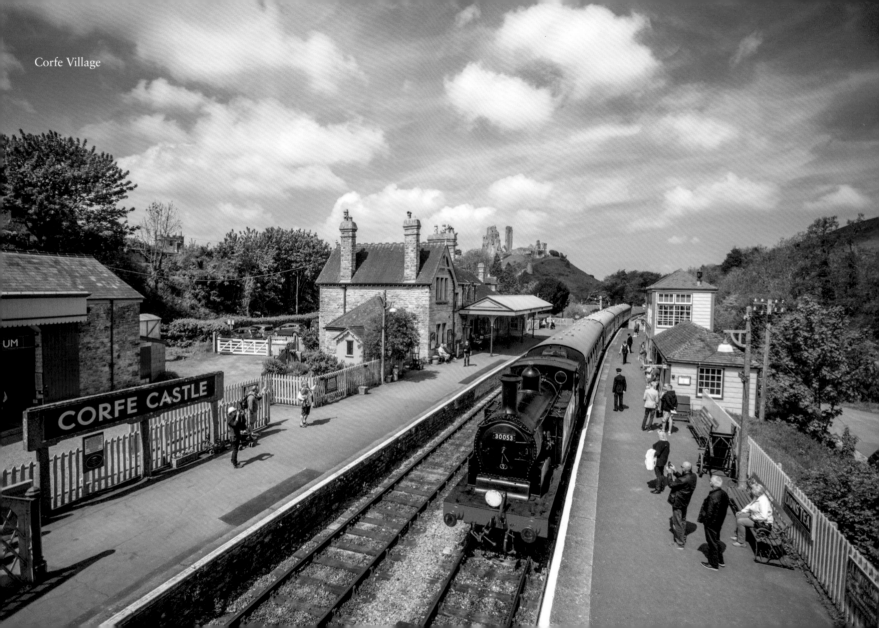

Corfe Village

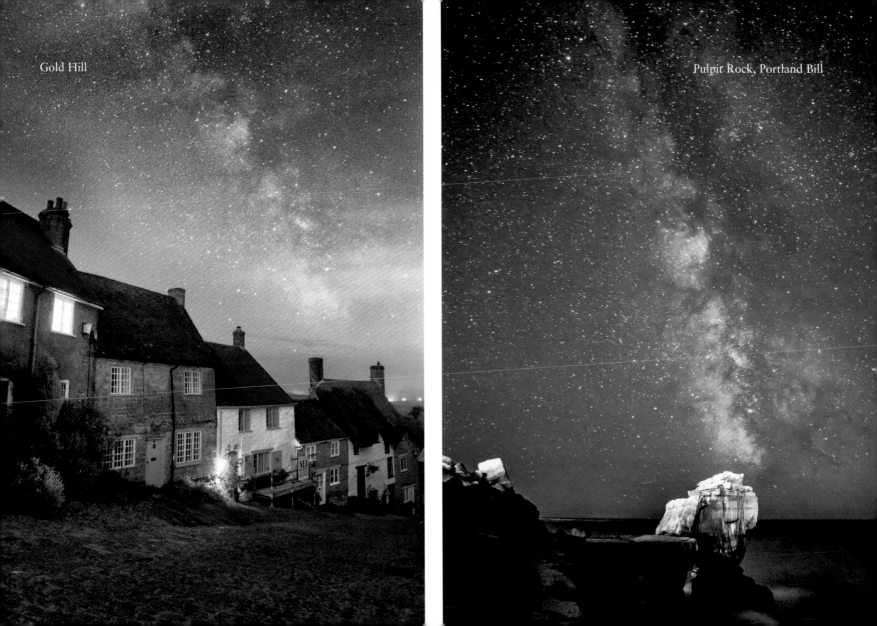

Gold Hill

Pulpit Rock, Portland Bill

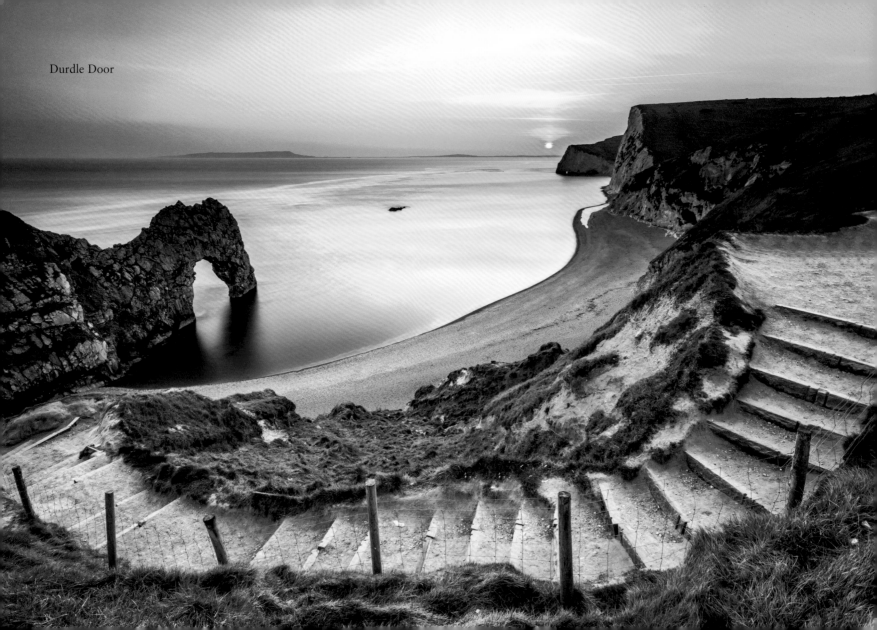

Durdle Door

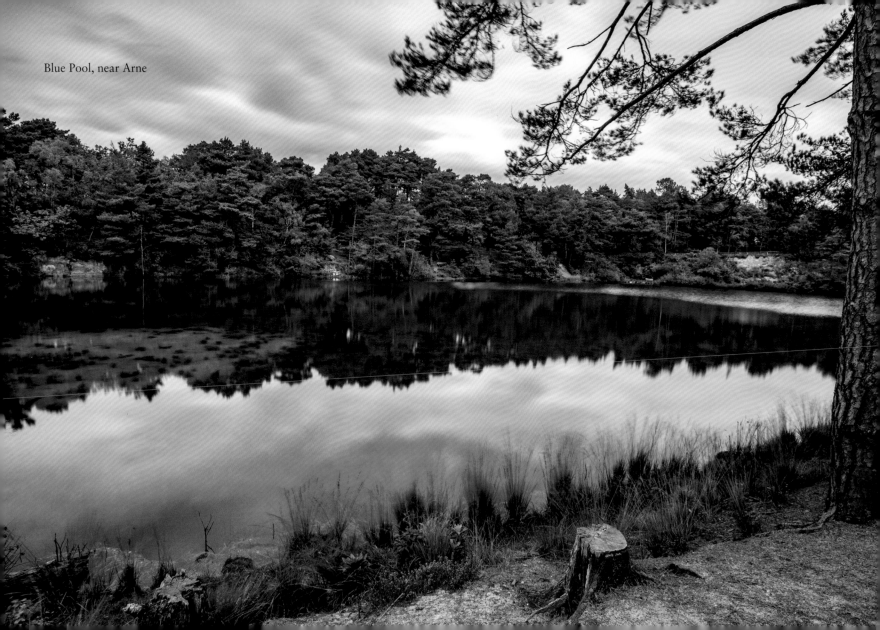
Blue Pool, near Arne

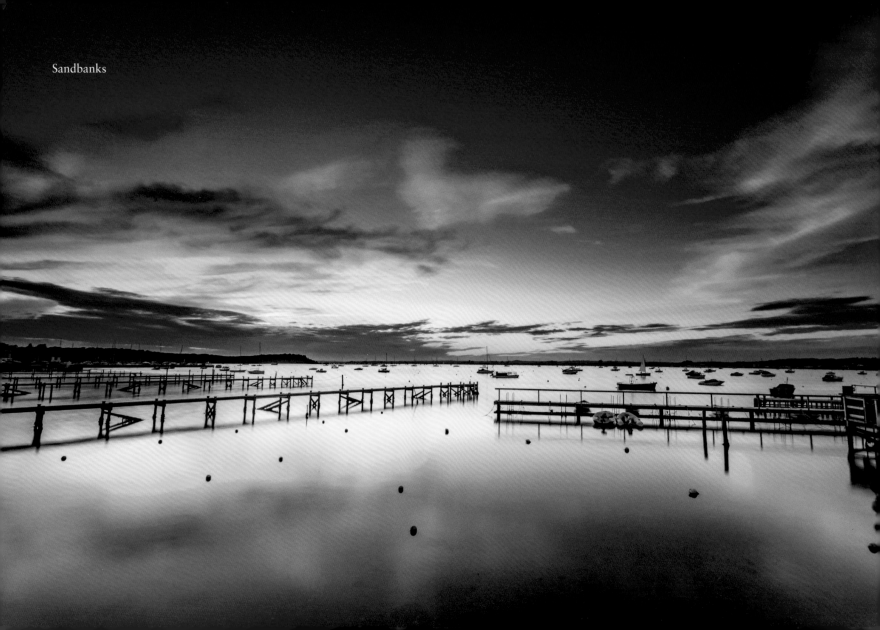

Sandbanks

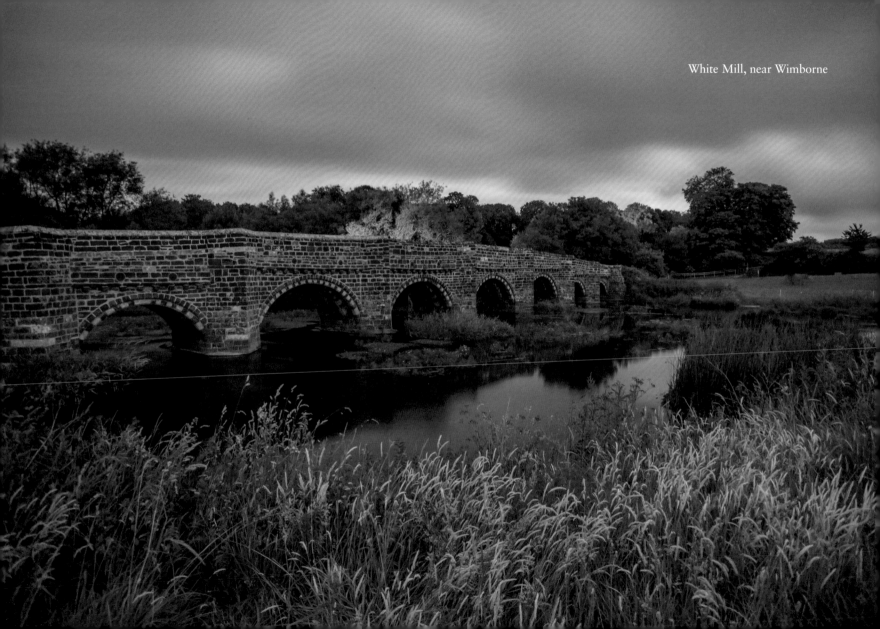
White Mill, near Wimborne

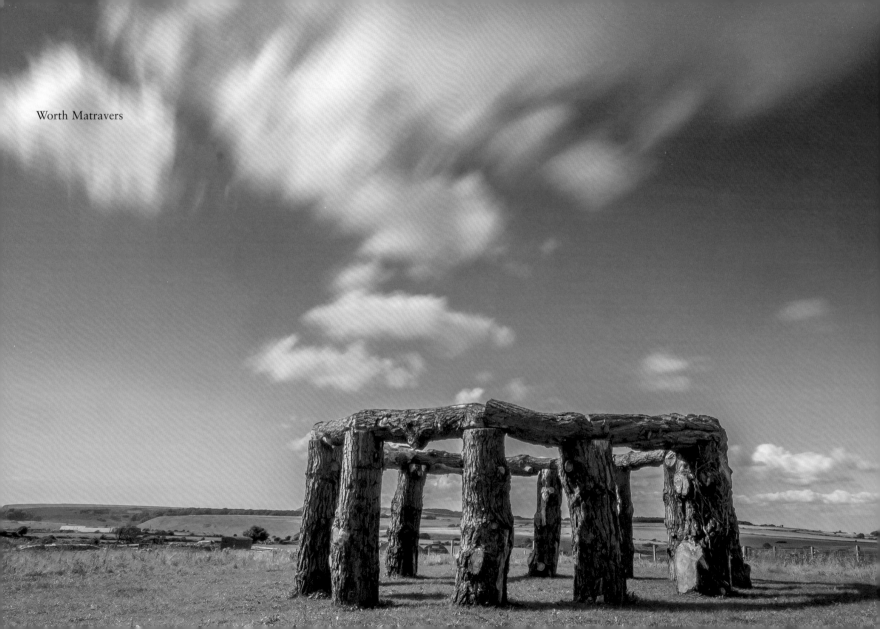

Worth Matravers

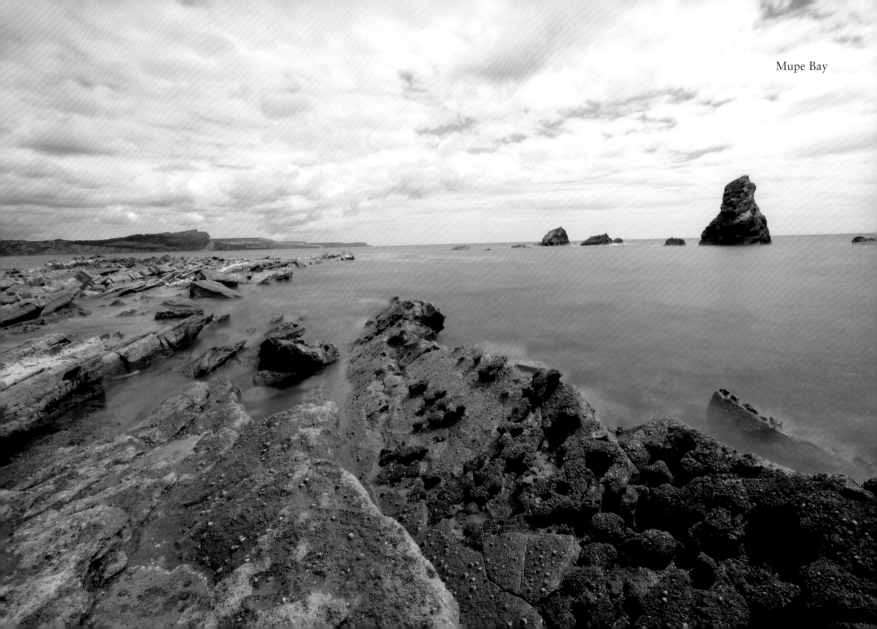

Mupe Bay

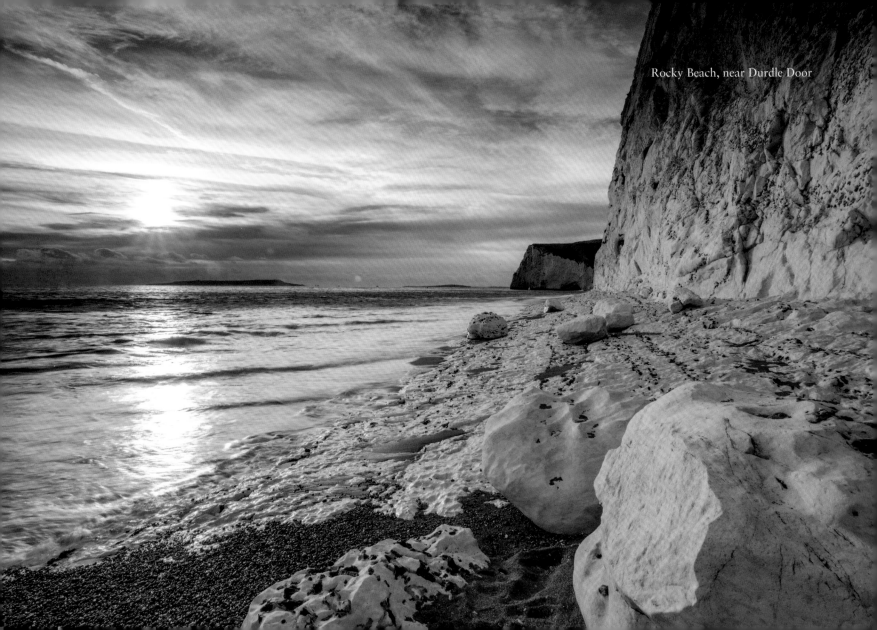

Rocky Beach, near Durdle Door

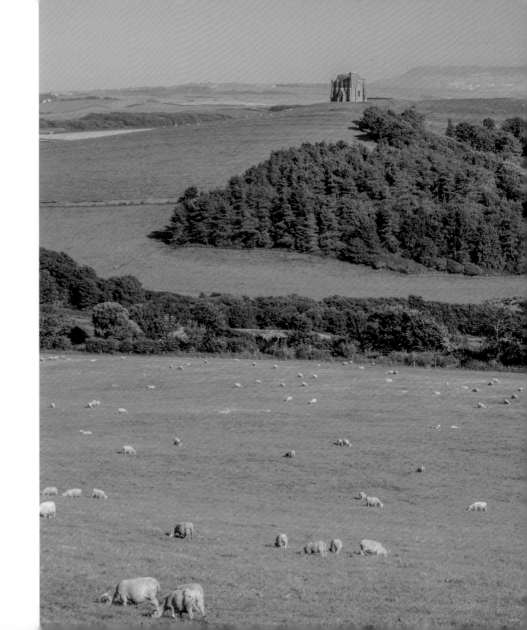

St Catherine's Church, Abbotsbury

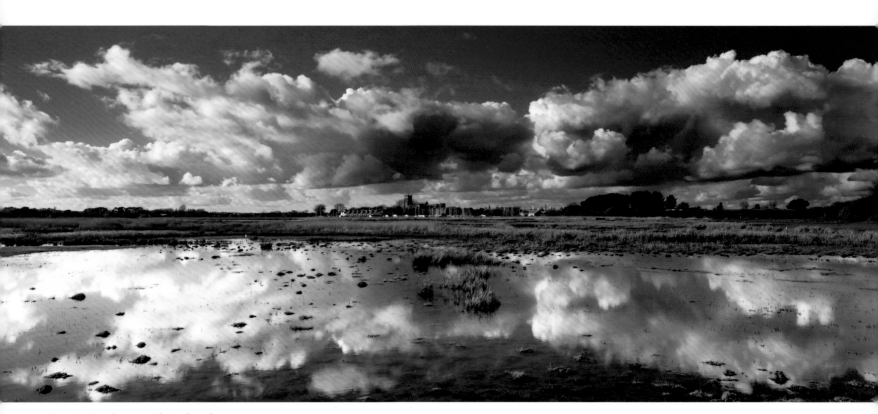

Stanpit Marsh, near Christchurch

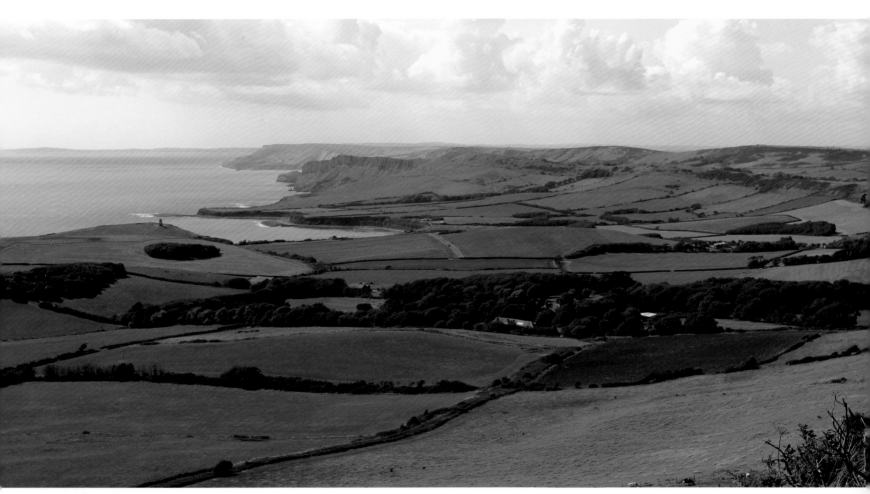

Kimmeridge Valley

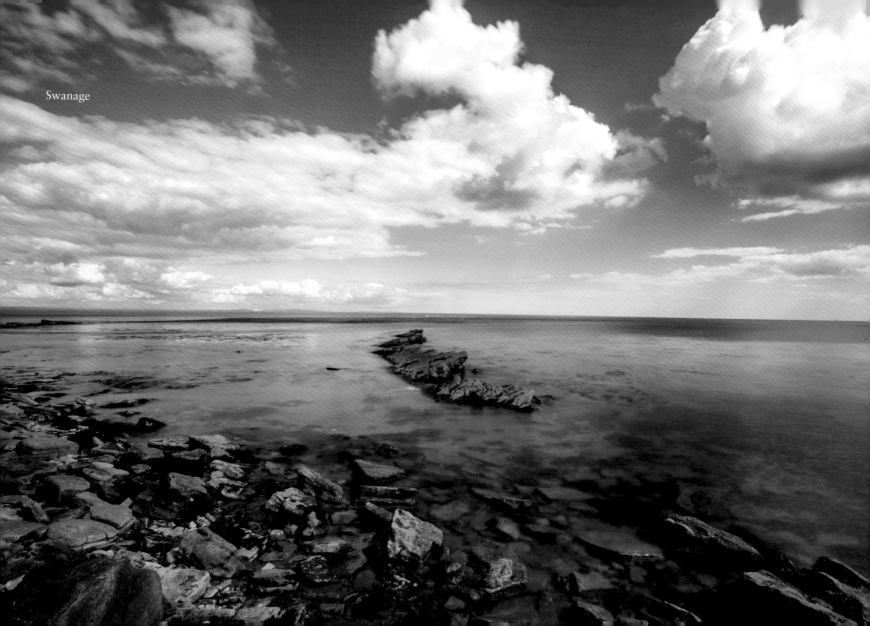
Swanage

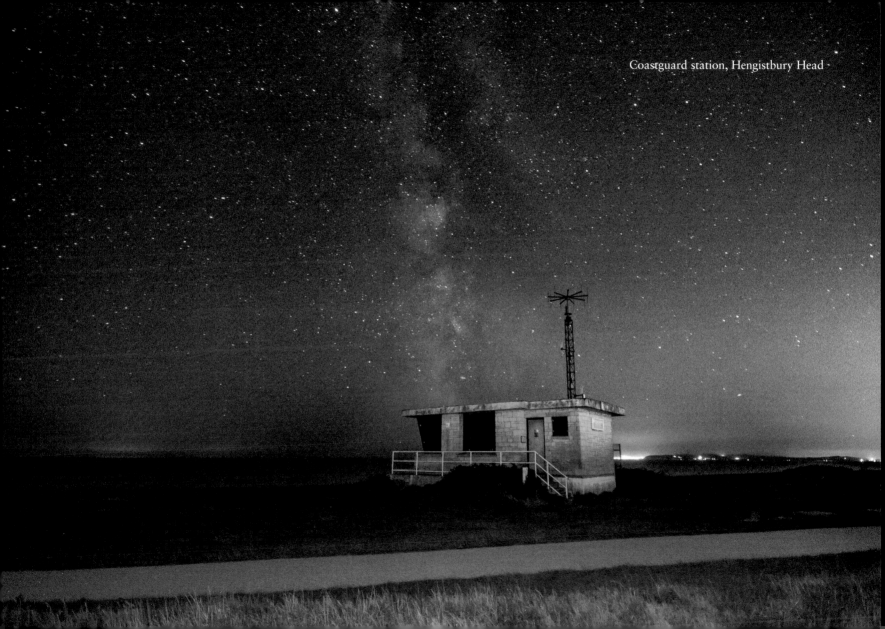

Coastguard station, Hengistbury Head

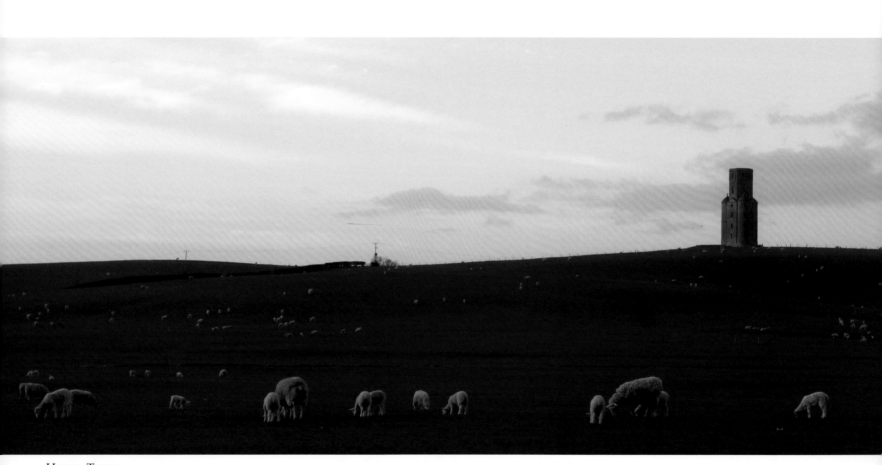

Horton Tower

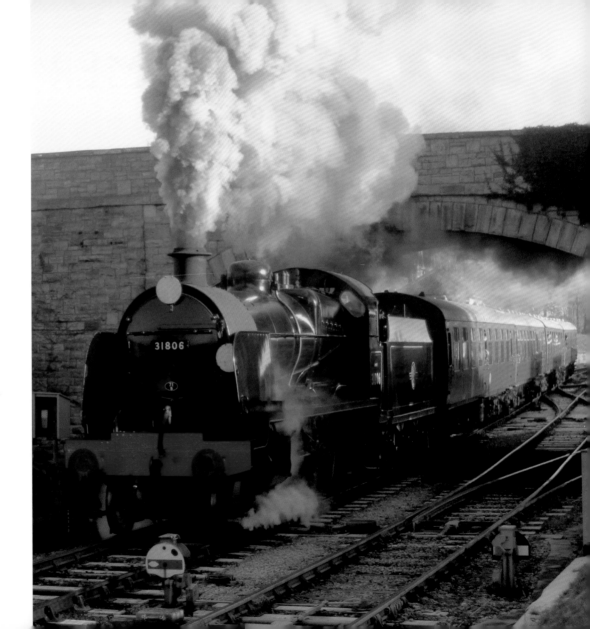

Corfe Village

SUMMER

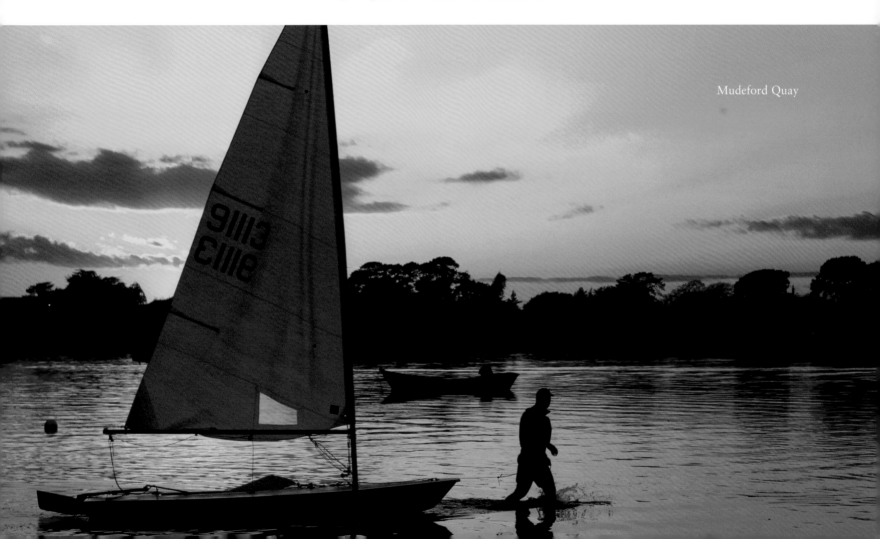

Mudeford Quay

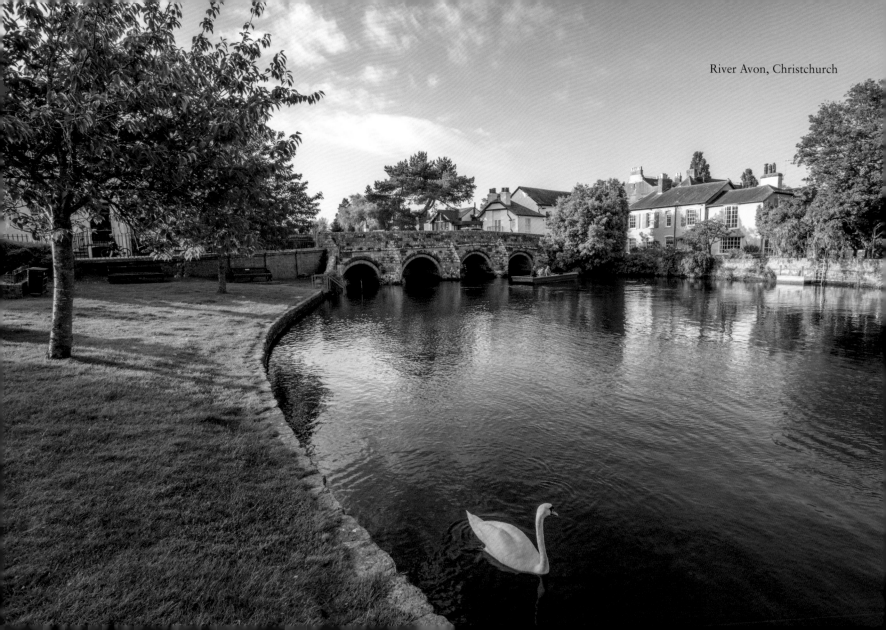

River Avon, Christchurch

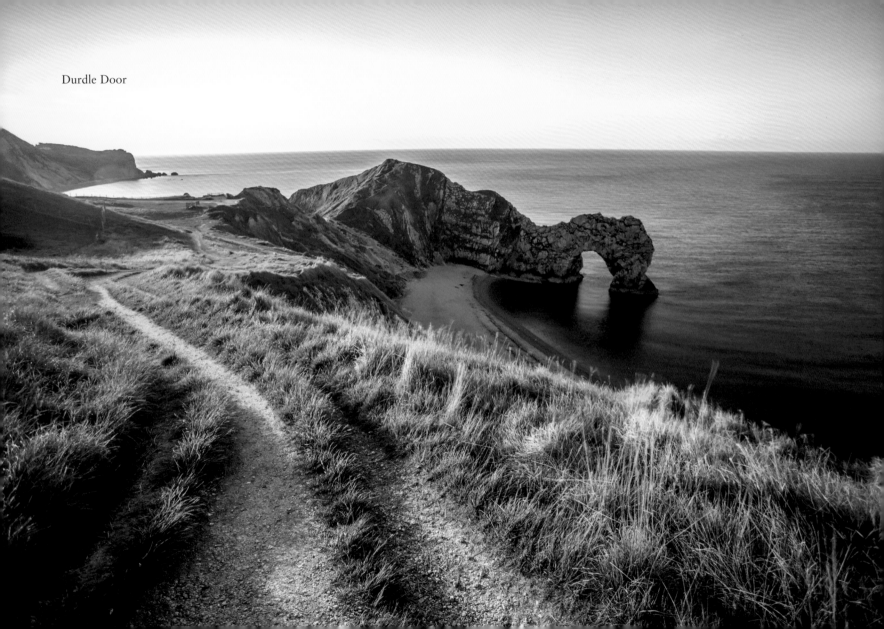

Durdle Door

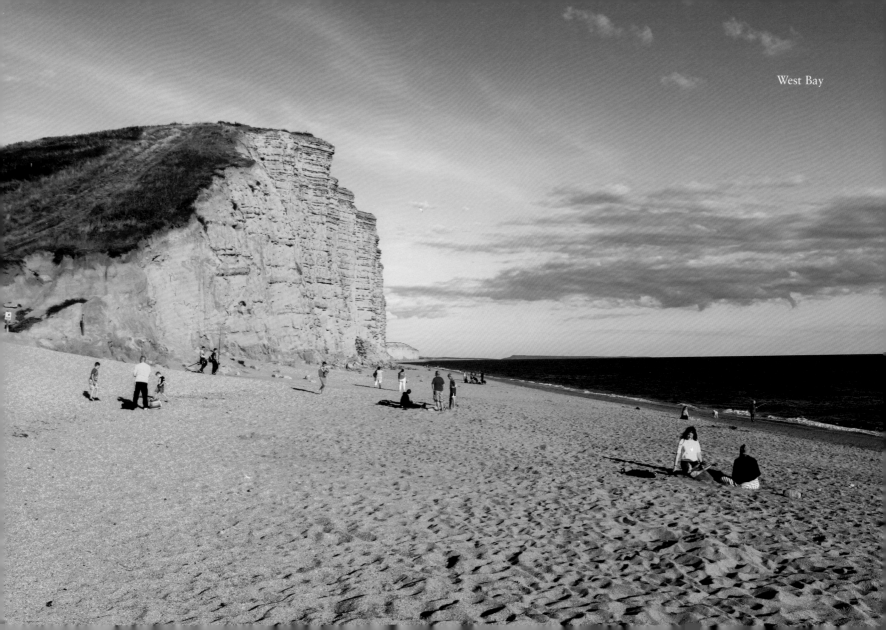

West Bay

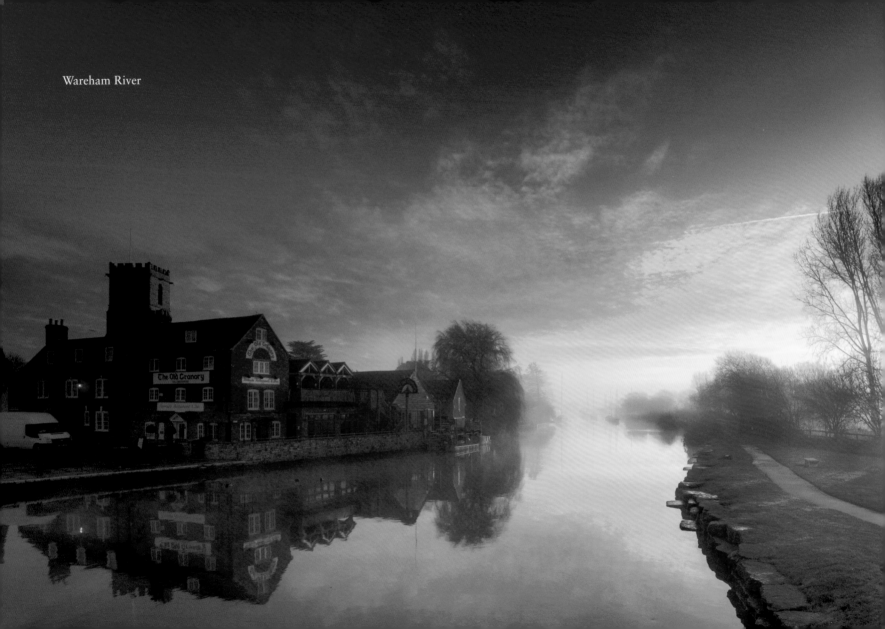

Wareham River

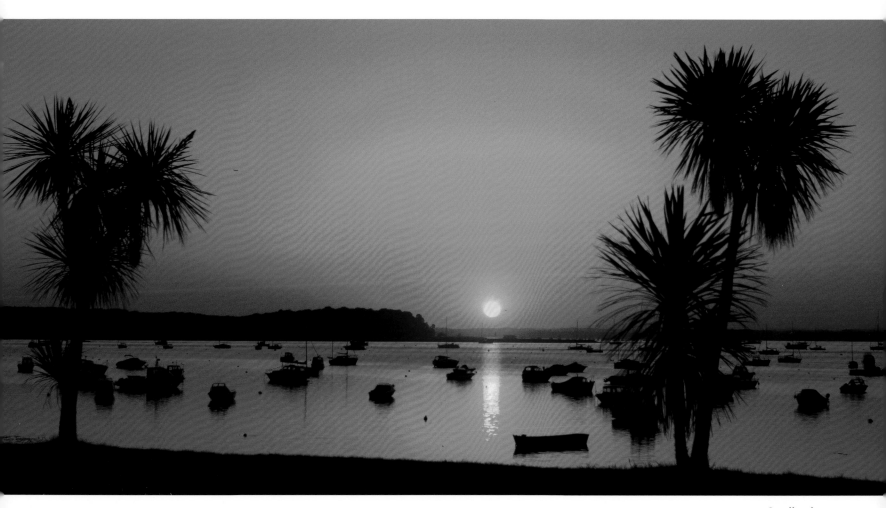

Sandbanks

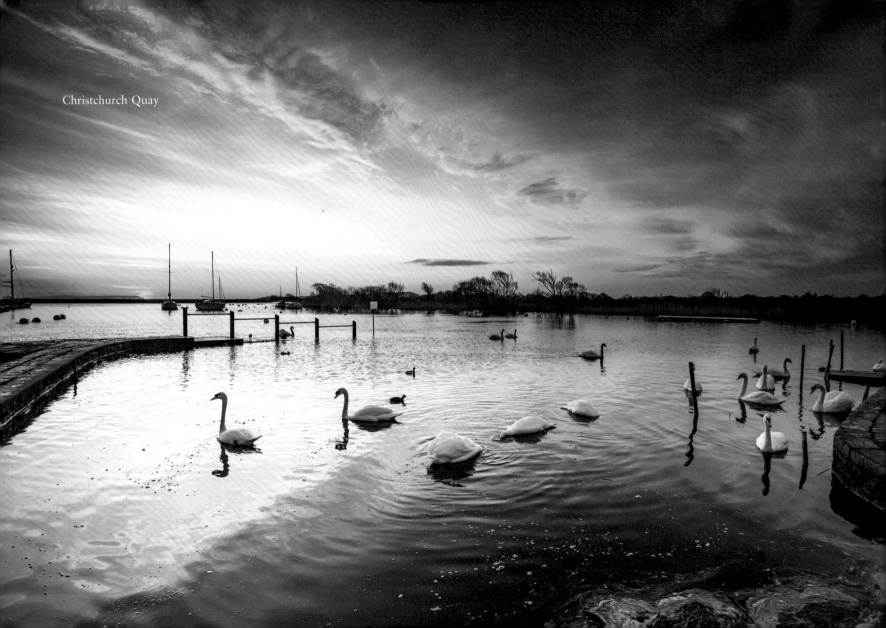

Christchurch Quay

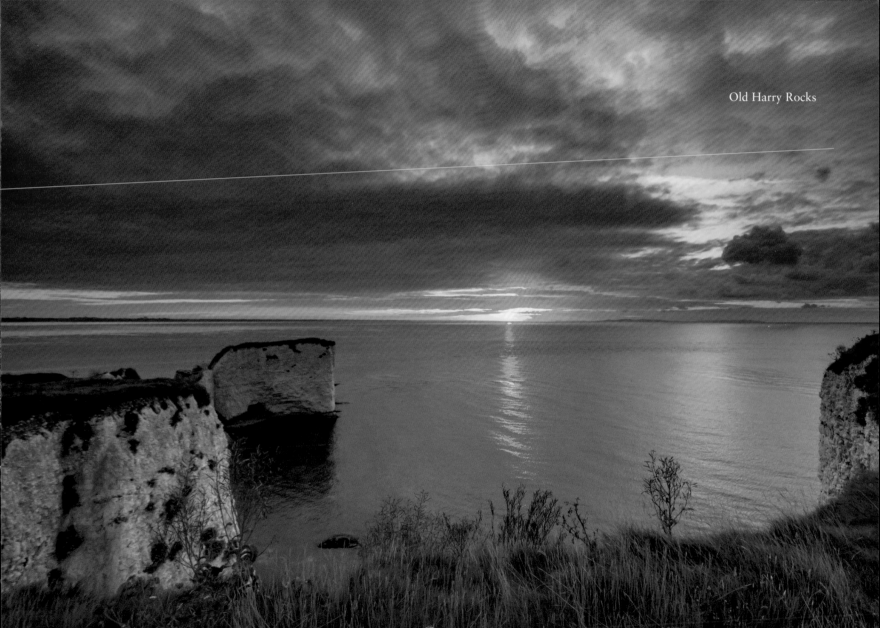

Old Harry Rocks

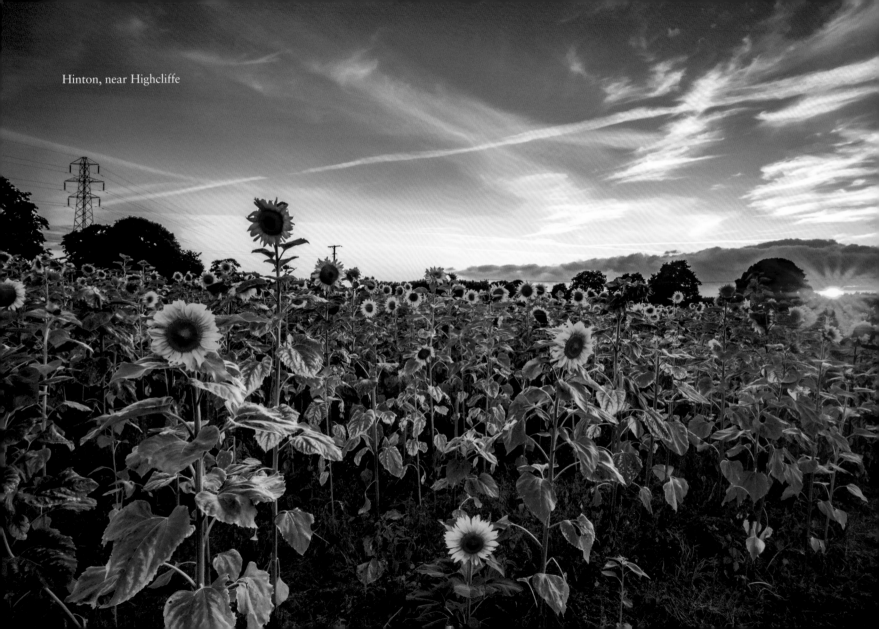

Hinton, near Highcliffe

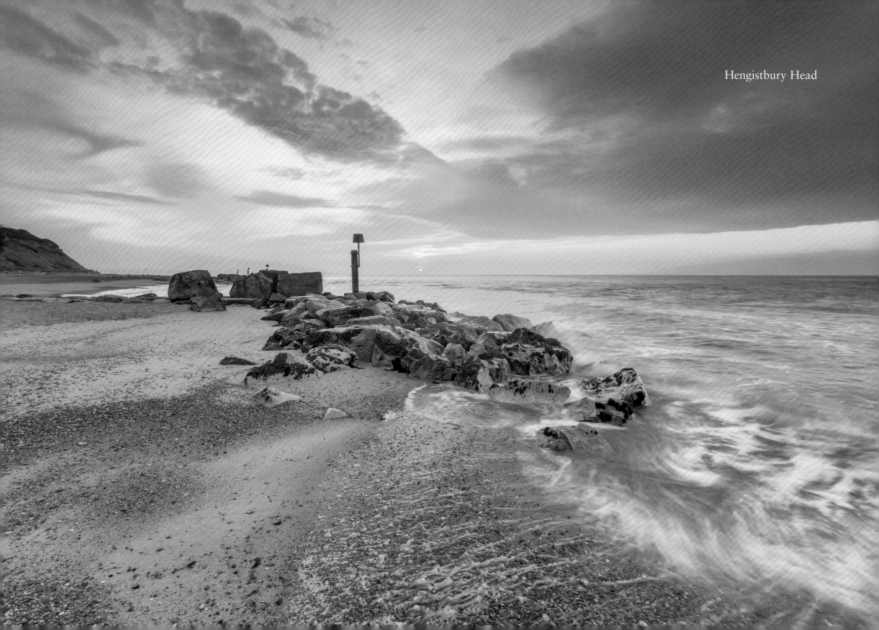

Hengistbury Head

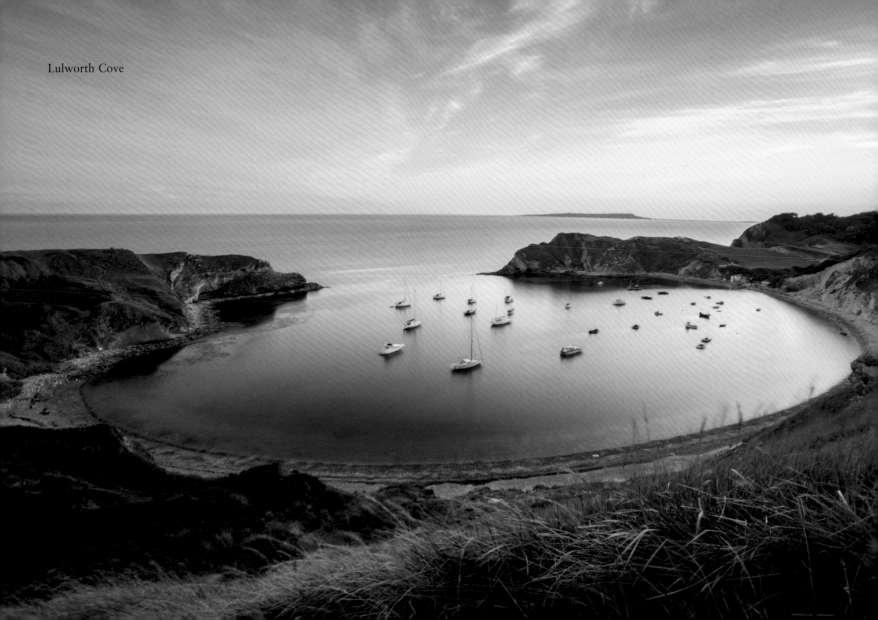

Lulworth Cove

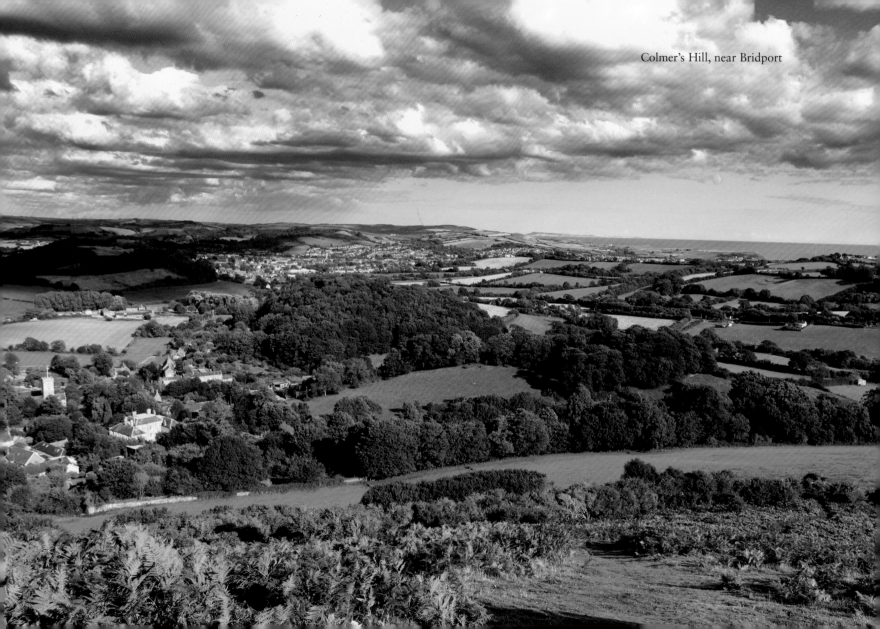

Colmer's Hill, near Bridport

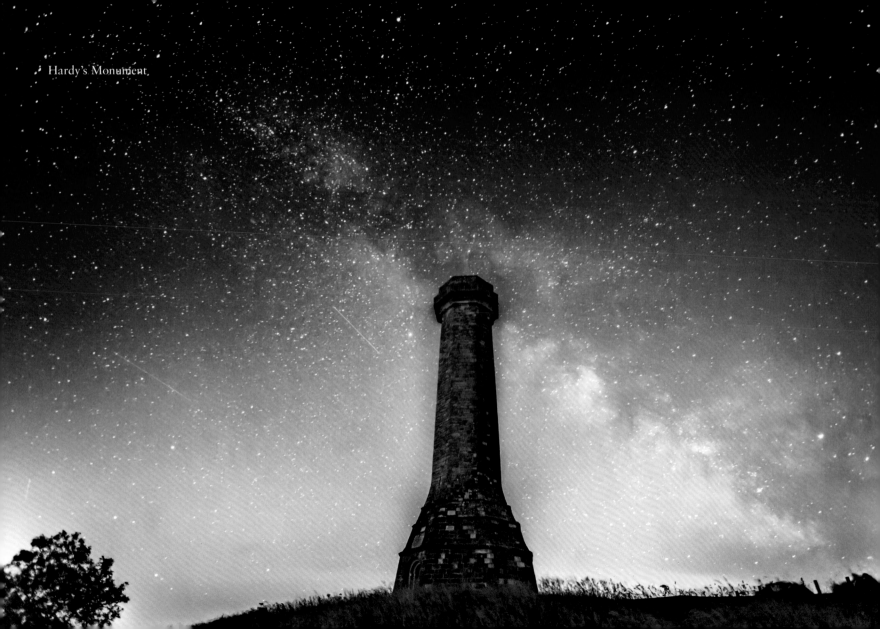

Hardy's Monument

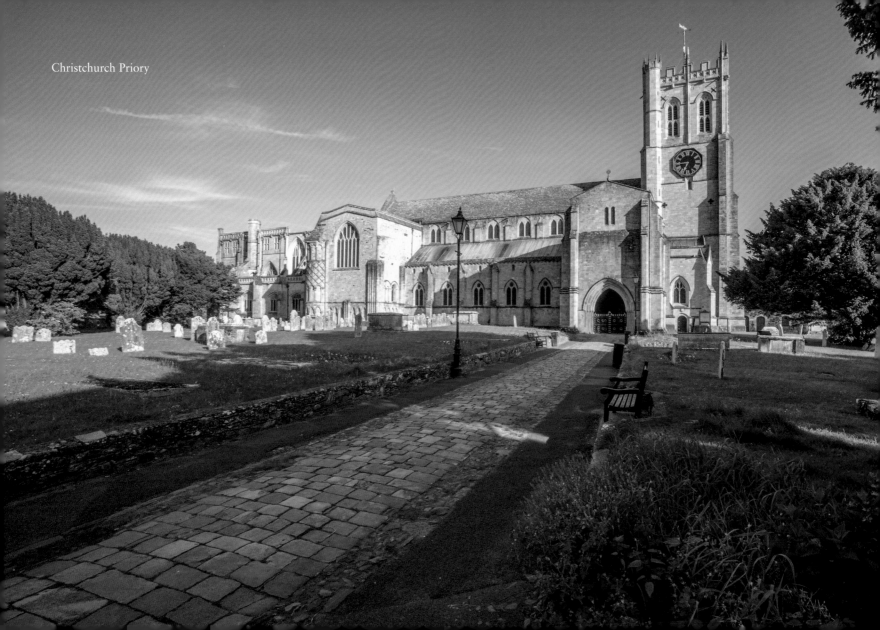

Christchurch Priory

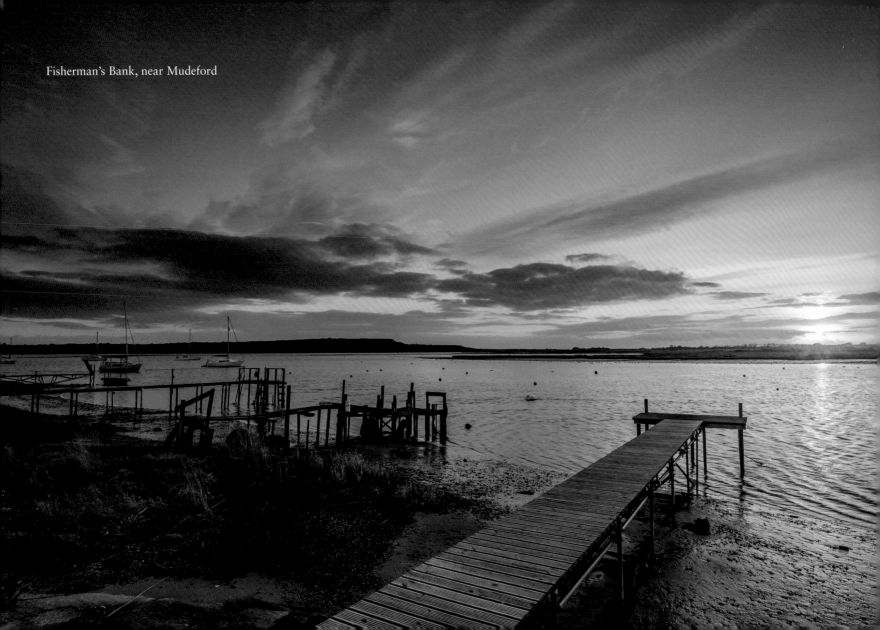

Fisherman's Bank, near Mudeford

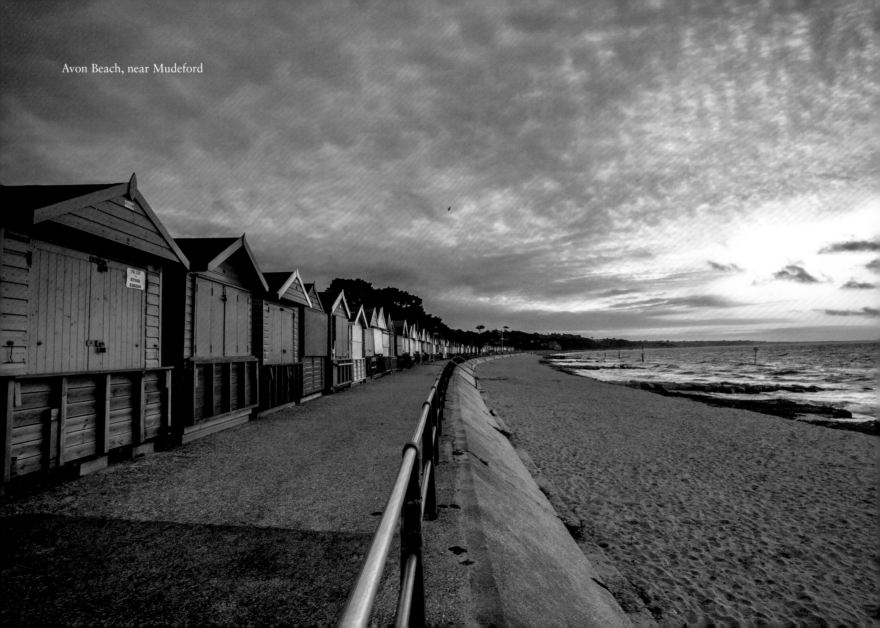

Avon Beach, near Mudeford

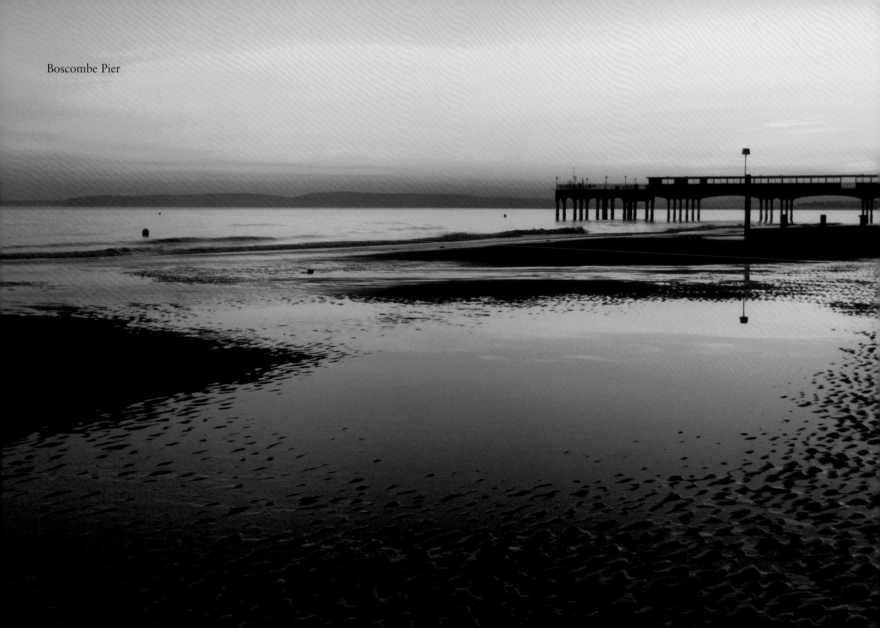

Boscombe Pier

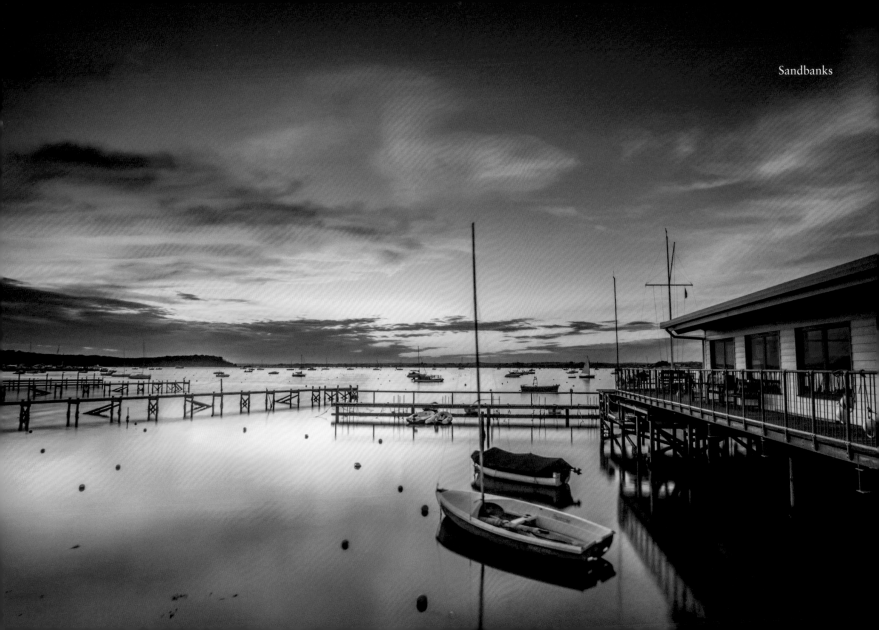

Sandbanks

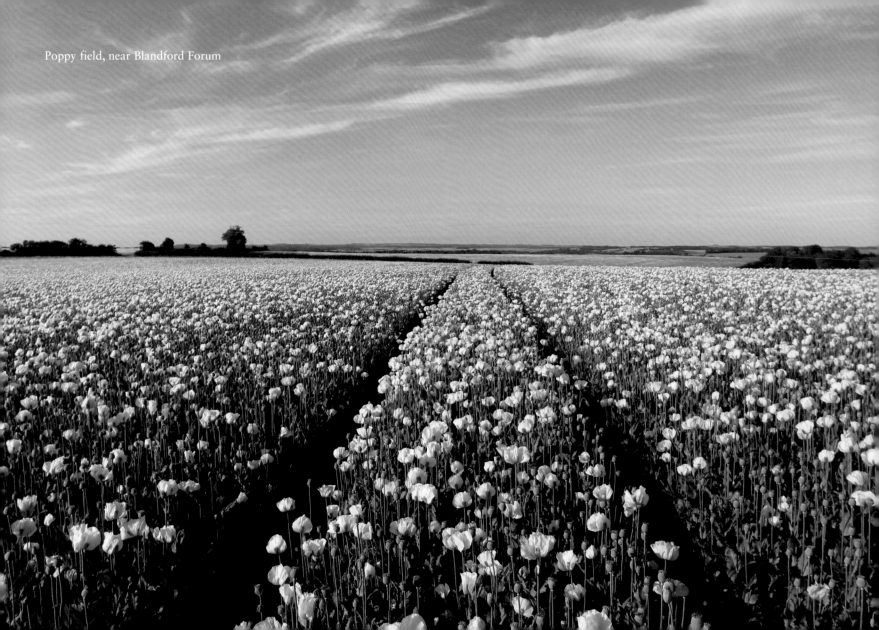

Poppy field, near Blandford Forum

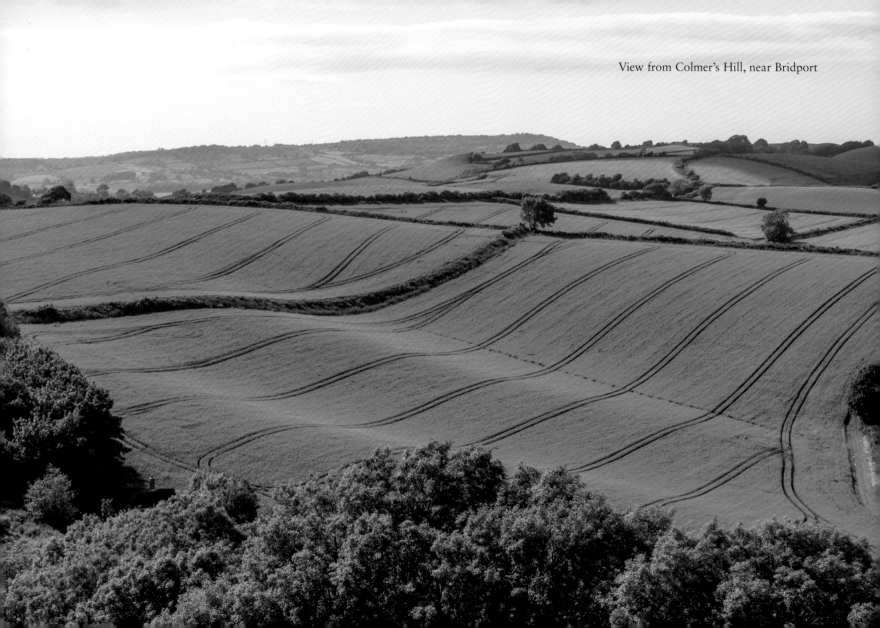

View from Colmer's Hill, near Bridport

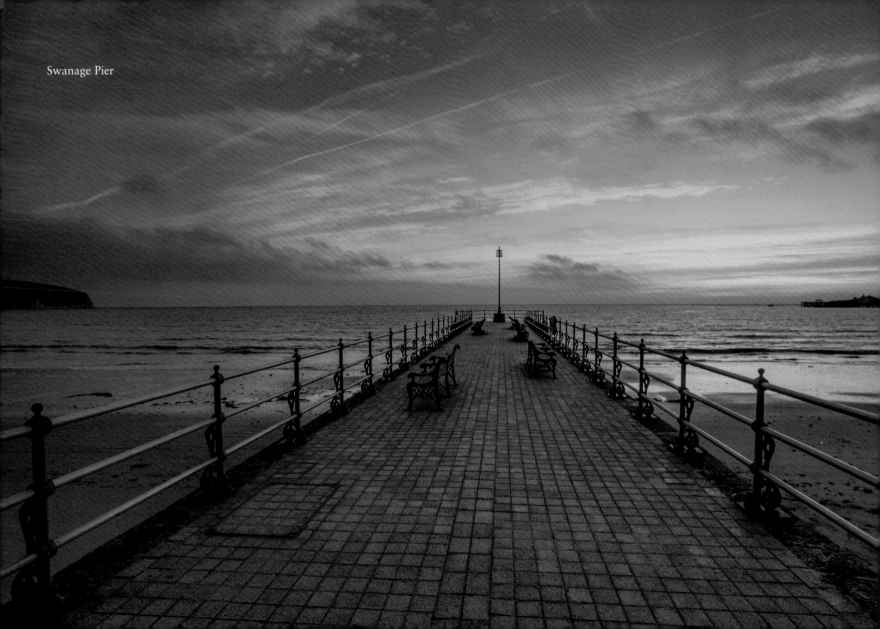

Swanage Pier

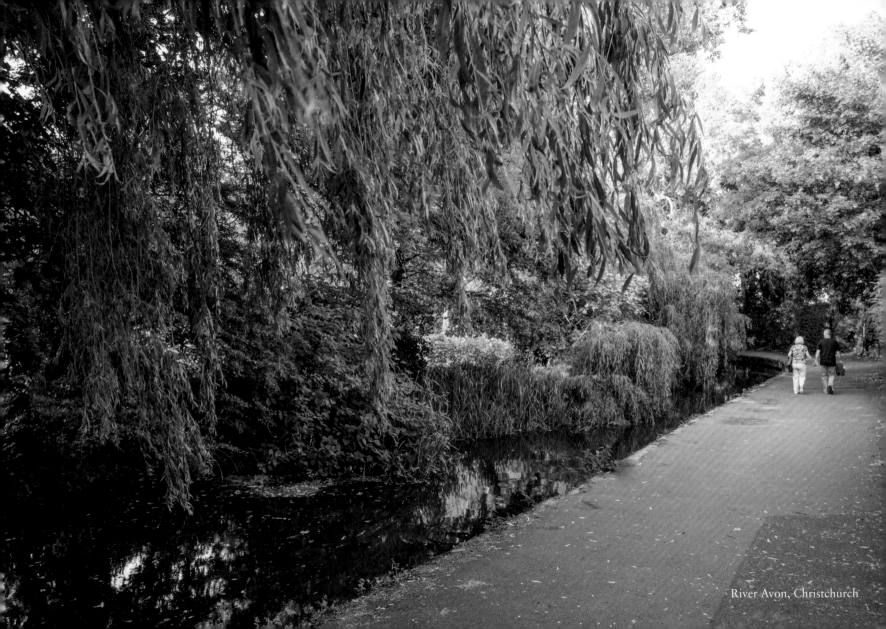

River Avon, Christchurch

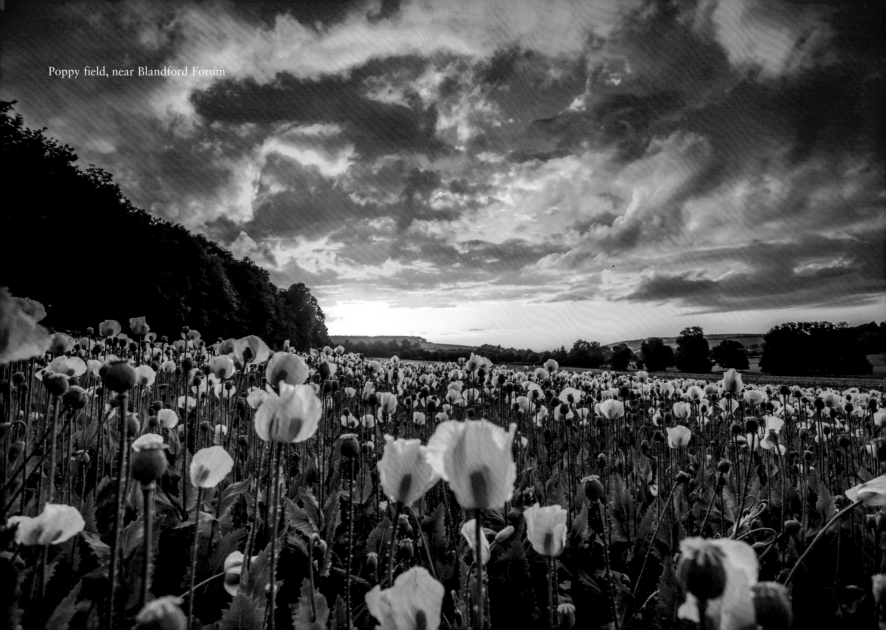
Poppy field, near Blandford Forum

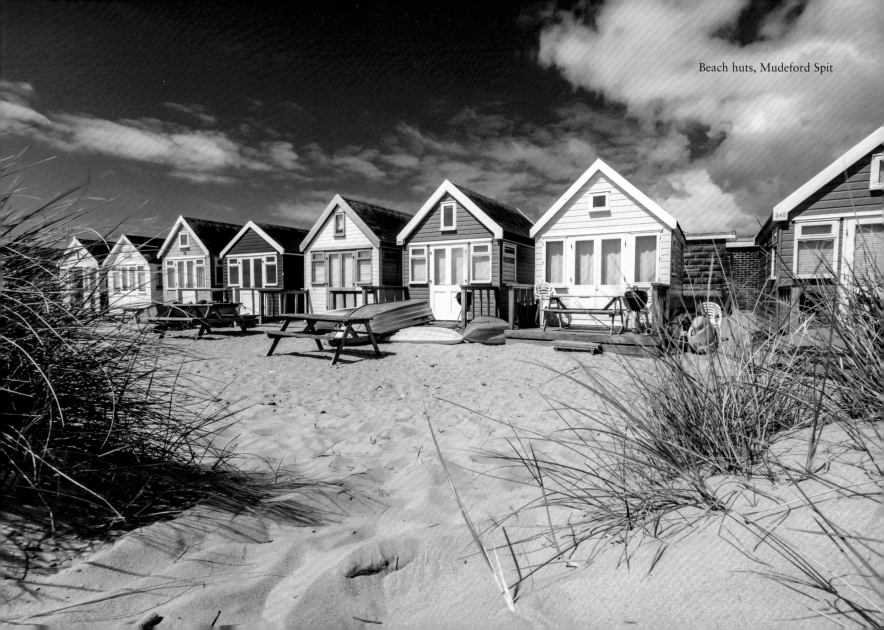
Beach huts, Mudeford Spit

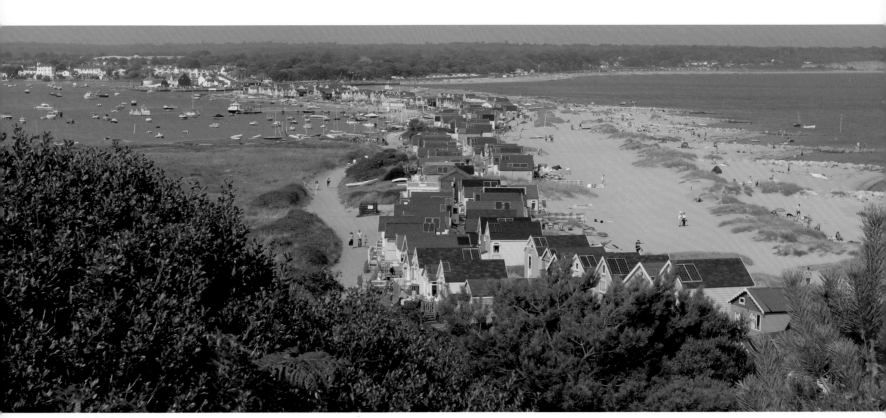

Mudeford Spit

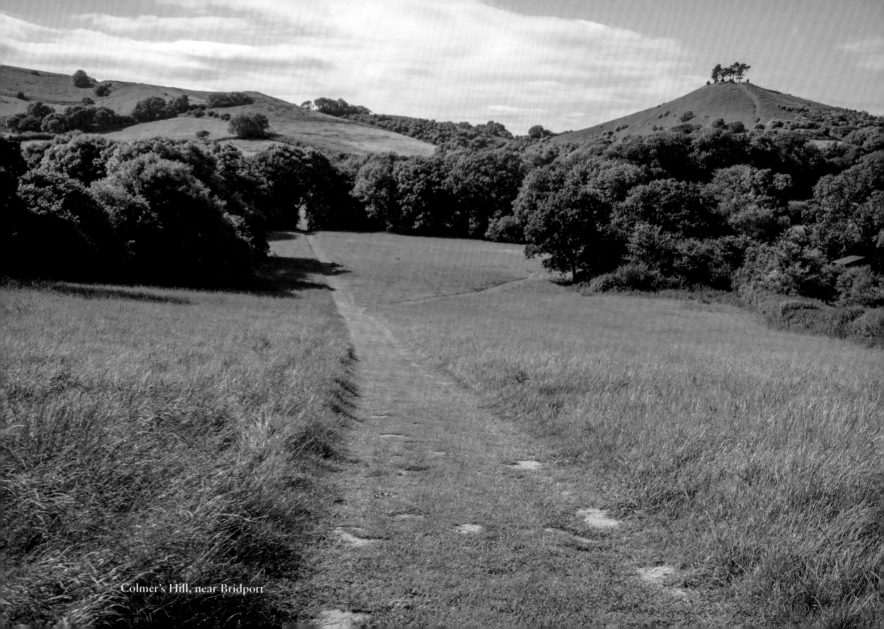

Colmer's Hill, near Bridport

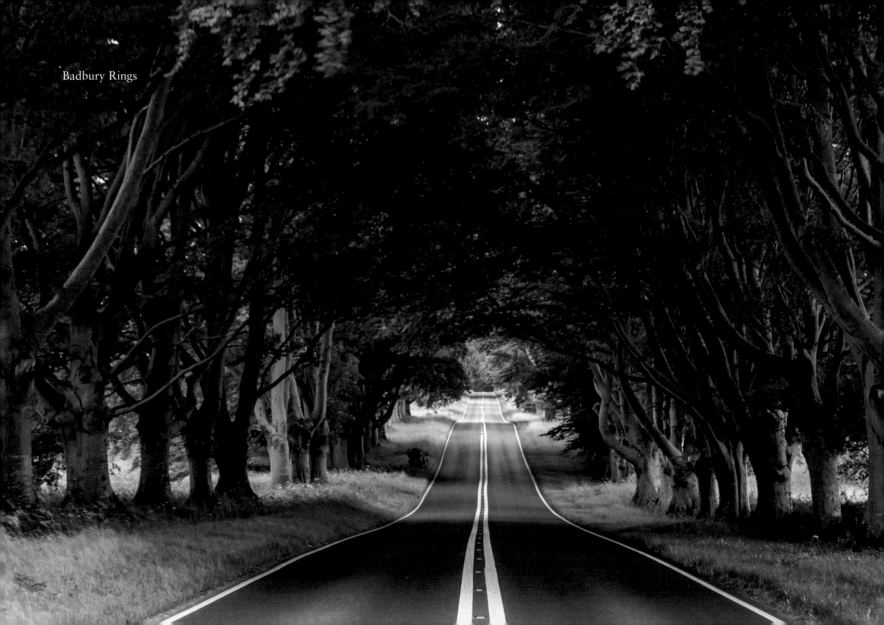

Badbury Rings

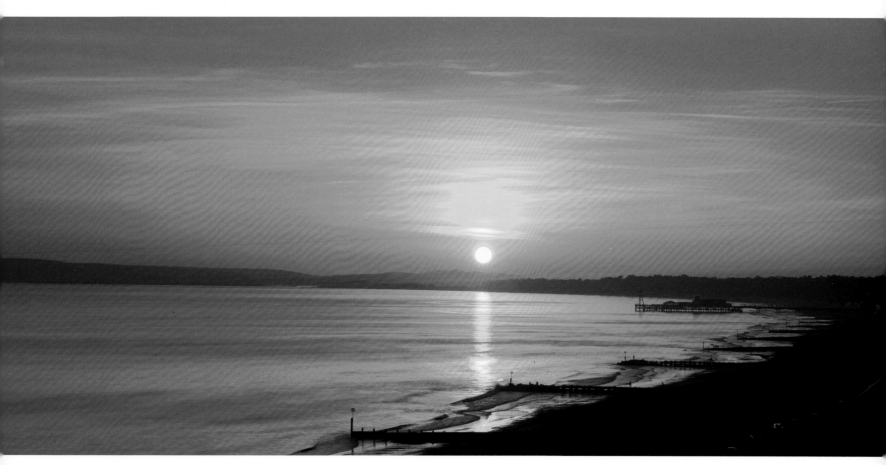

Bournemouth Pier

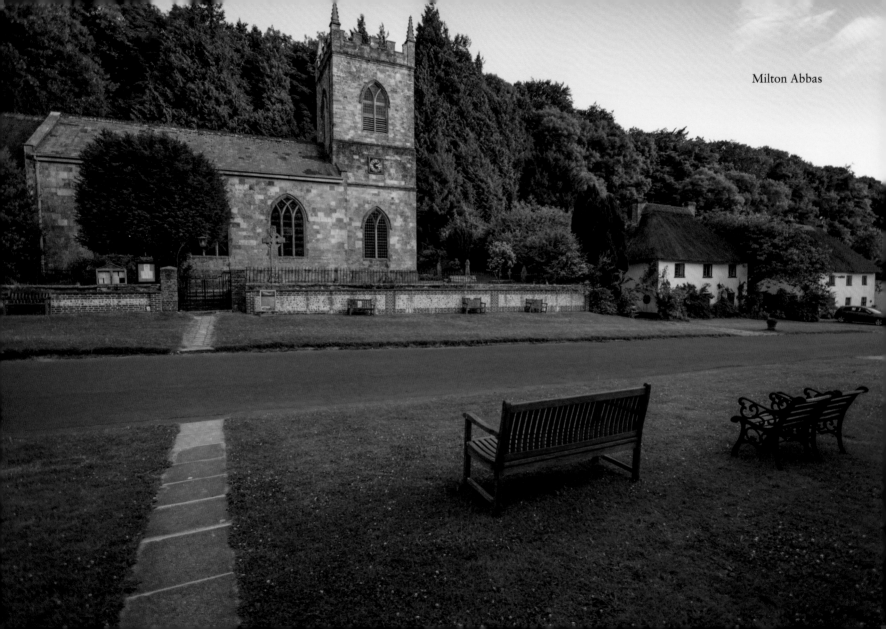

Milton Abbas

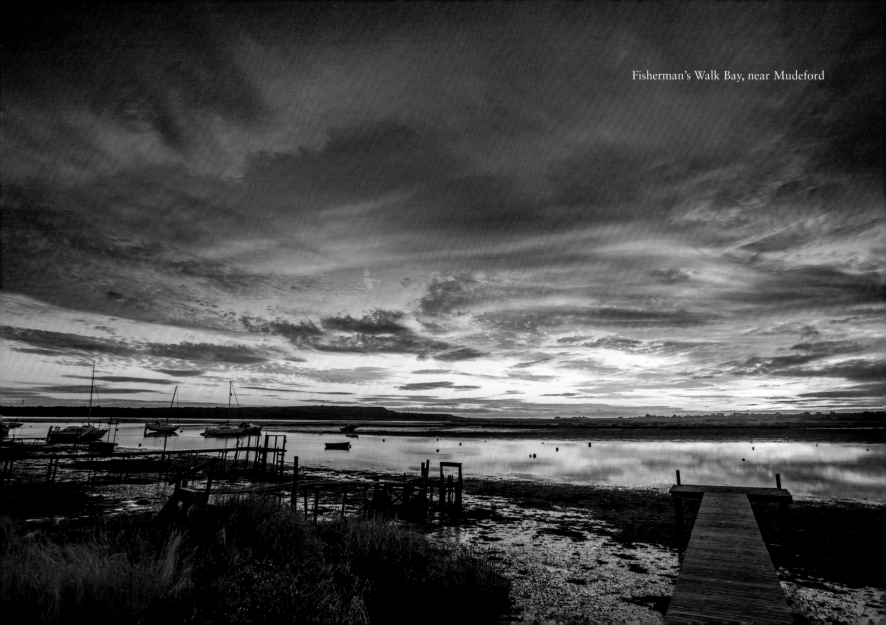

Fisherman's Walk Bay, near Mudeford

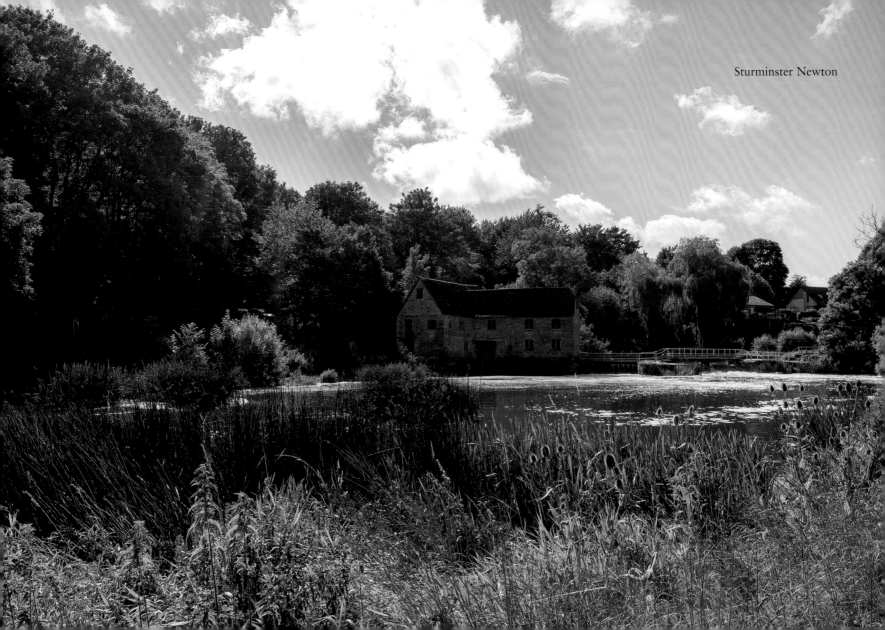

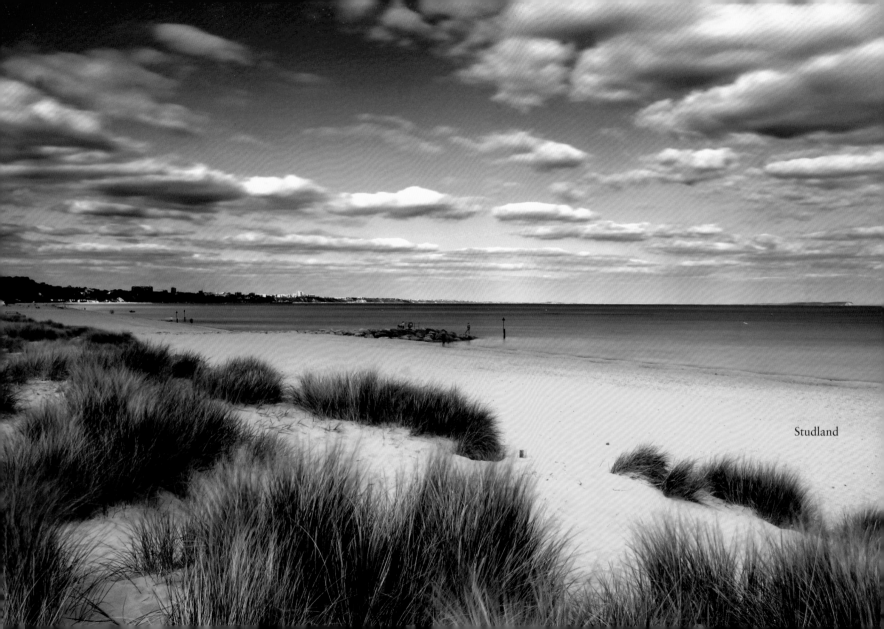

Studland

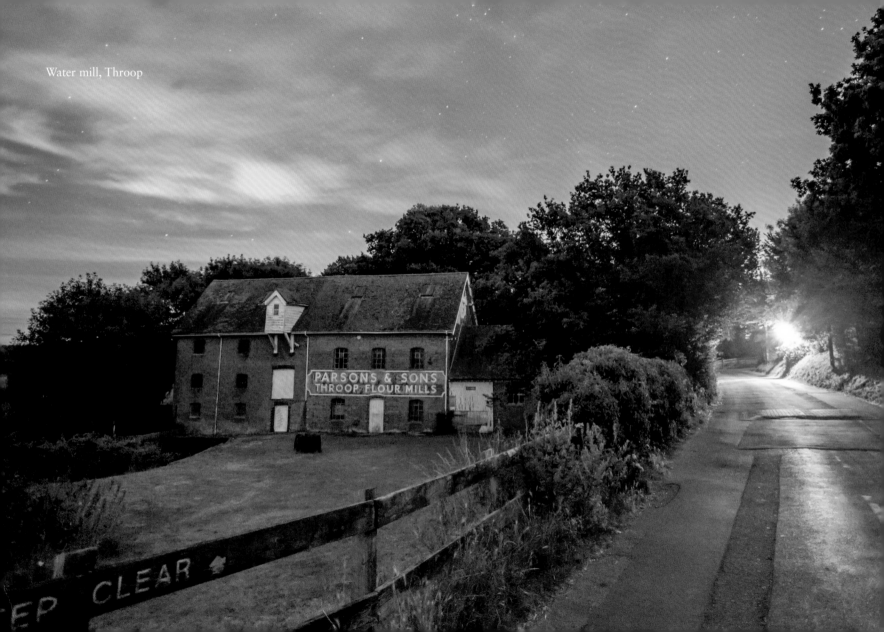

Water mill, Throop

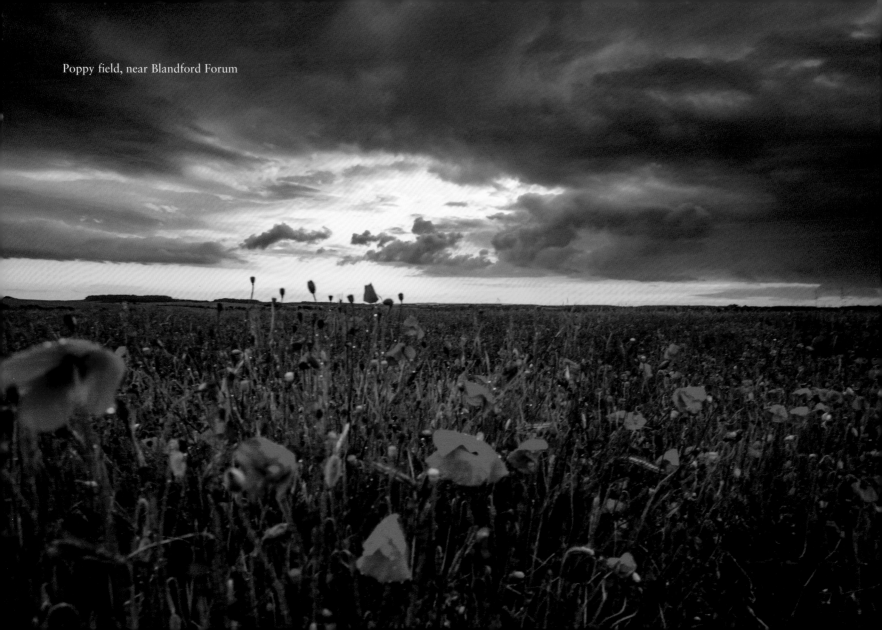

Poppy field, near Blandford Forum

AUTUMN

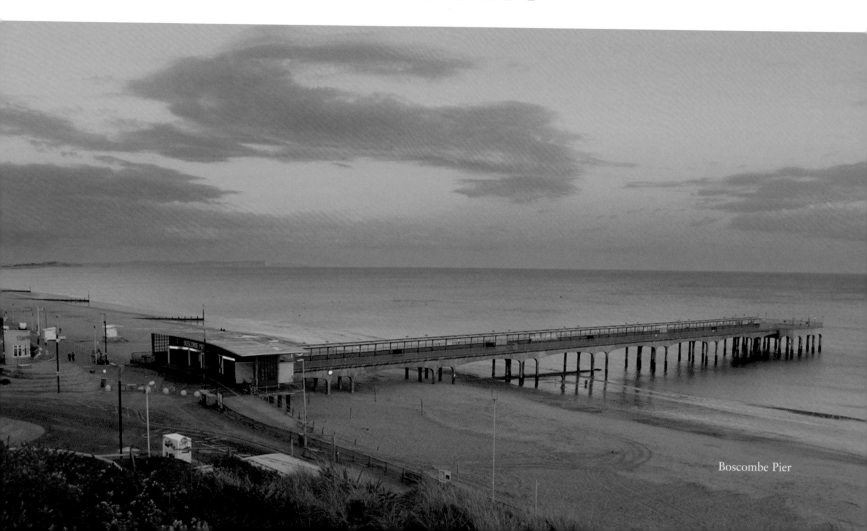

Boscombe Pier

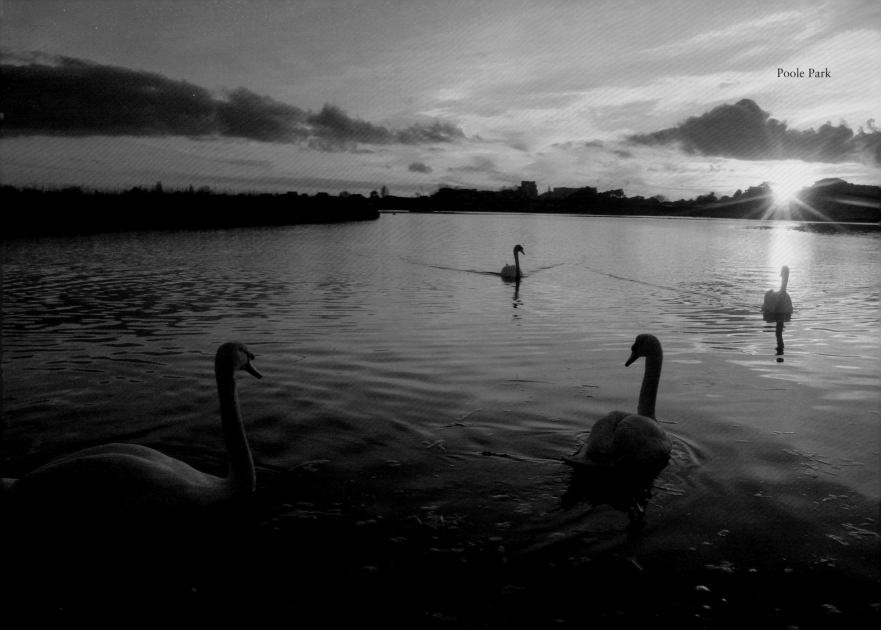

Poole Park

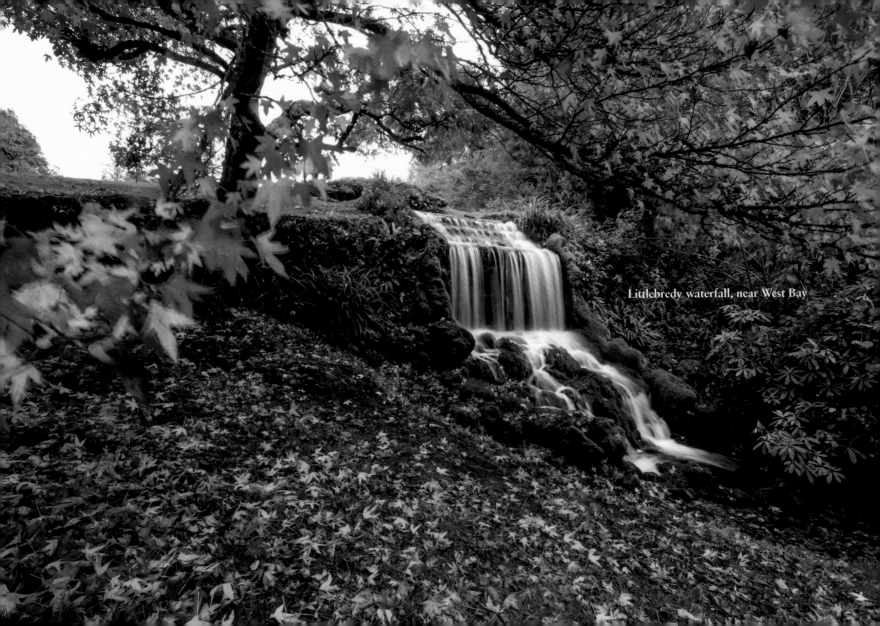

Littlebredy waterfall, near West Bay

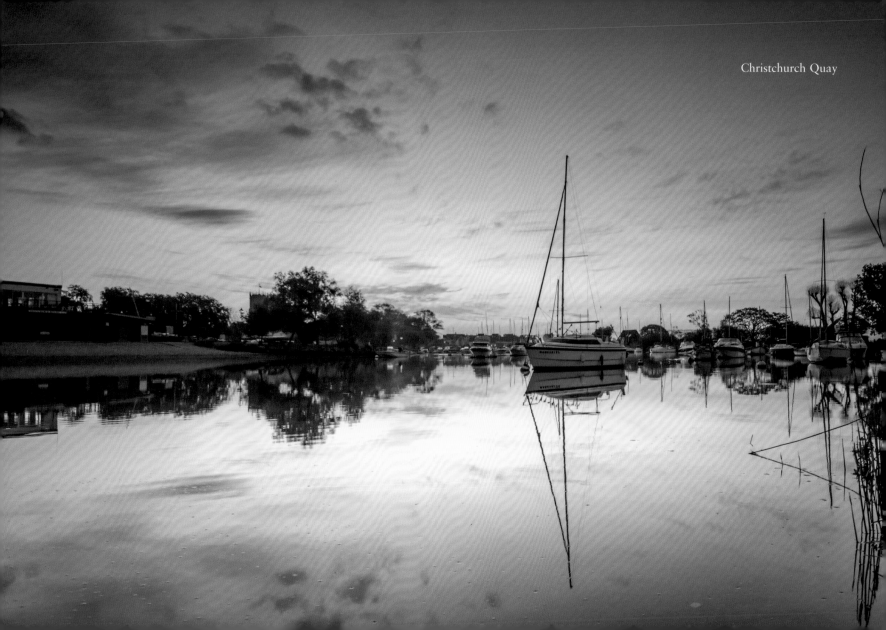

Christchurch Quay

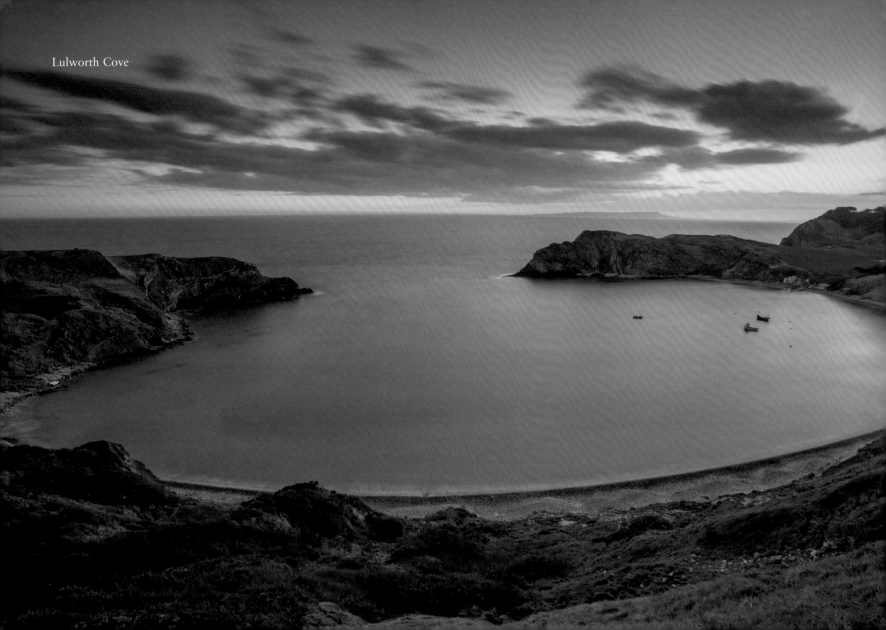
Lulworth Cove

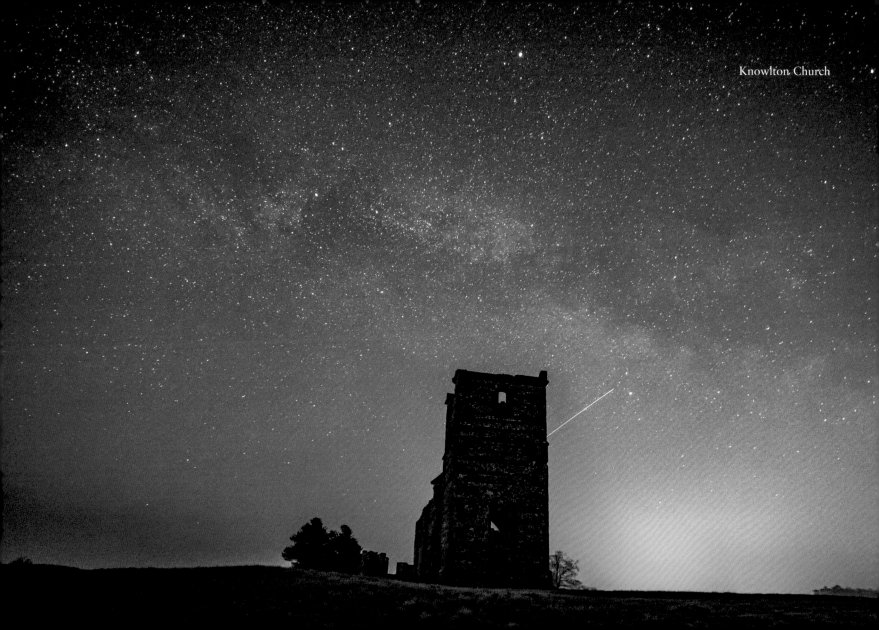

Knowlton Church

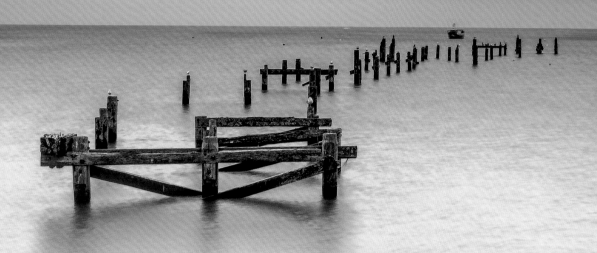

Old Swanage Pier

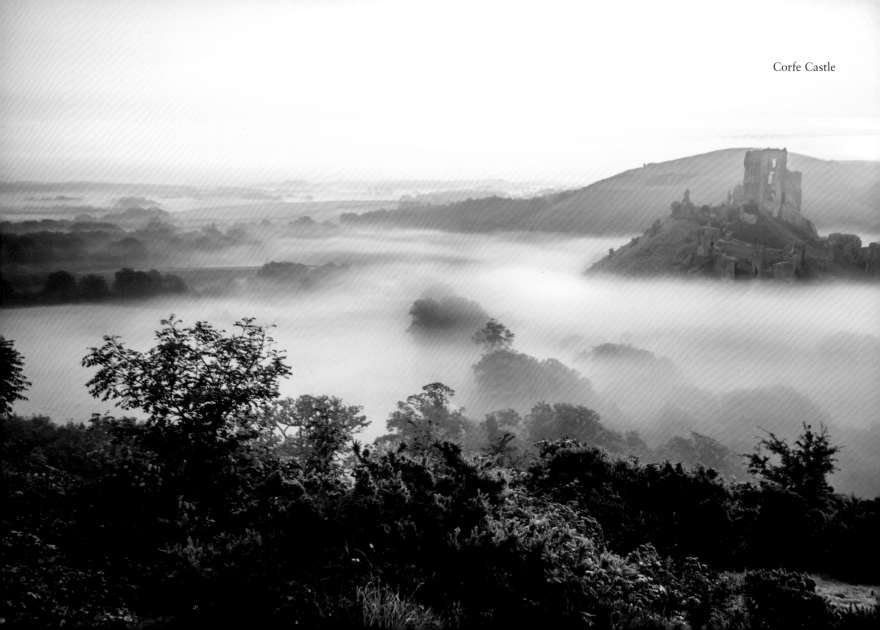

Corfe Castle

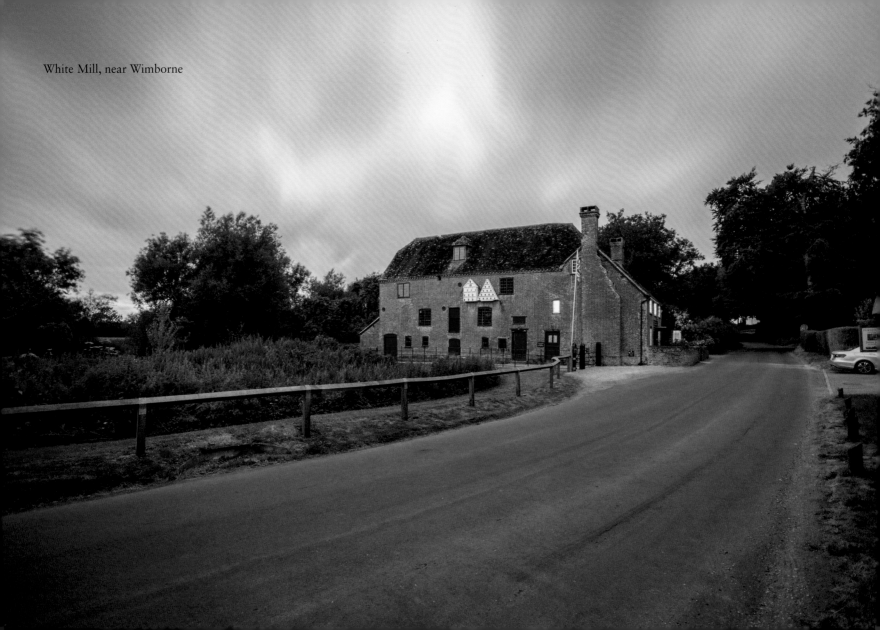

White Mill, near Wimborne

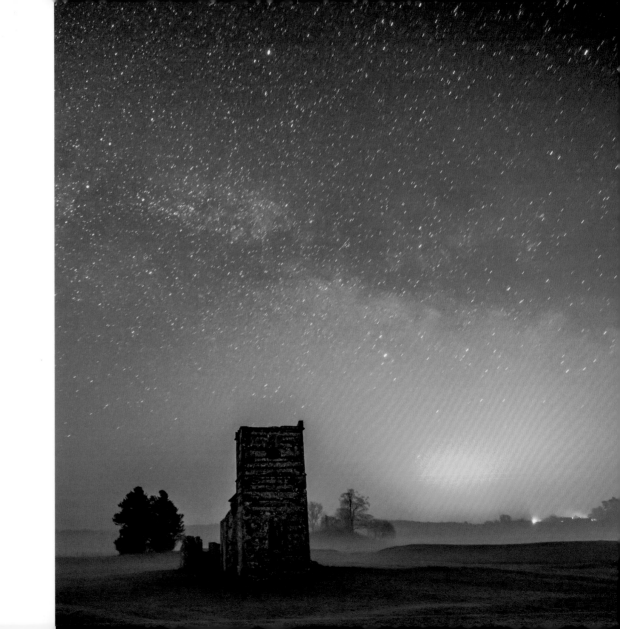

Knowlton Church

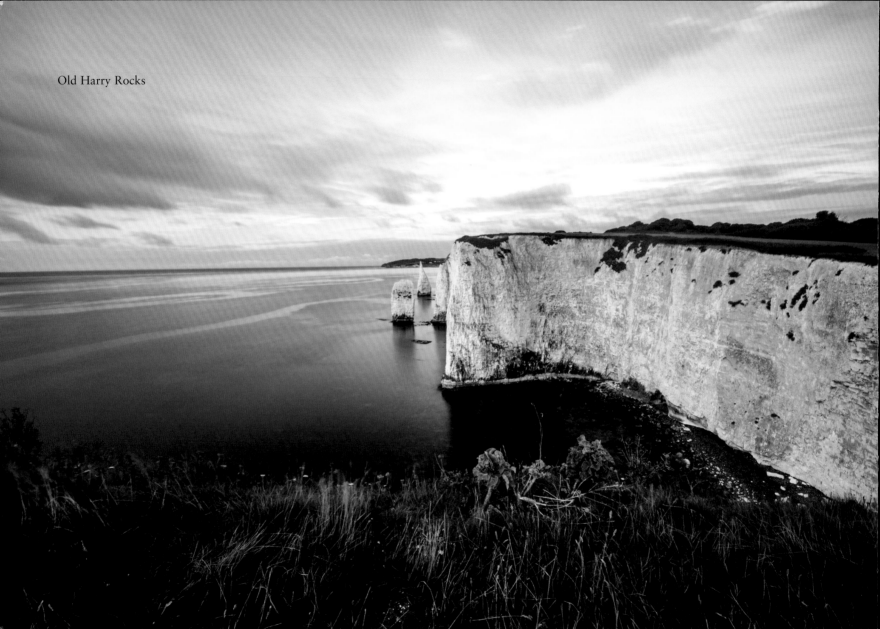

Old Harry Rocks

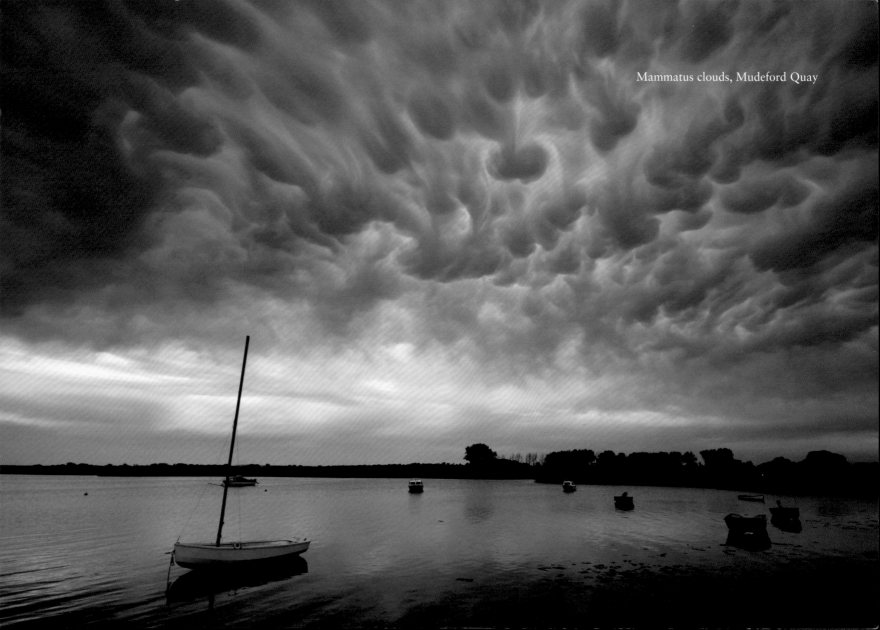

Mammatus clouds, Mudeford Quay

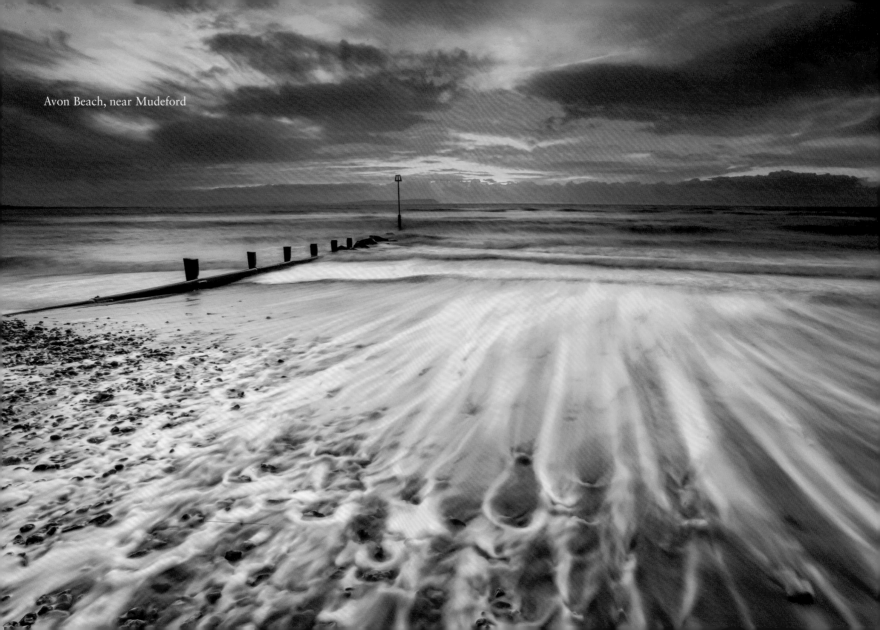

Avon Beach, near Mudeford

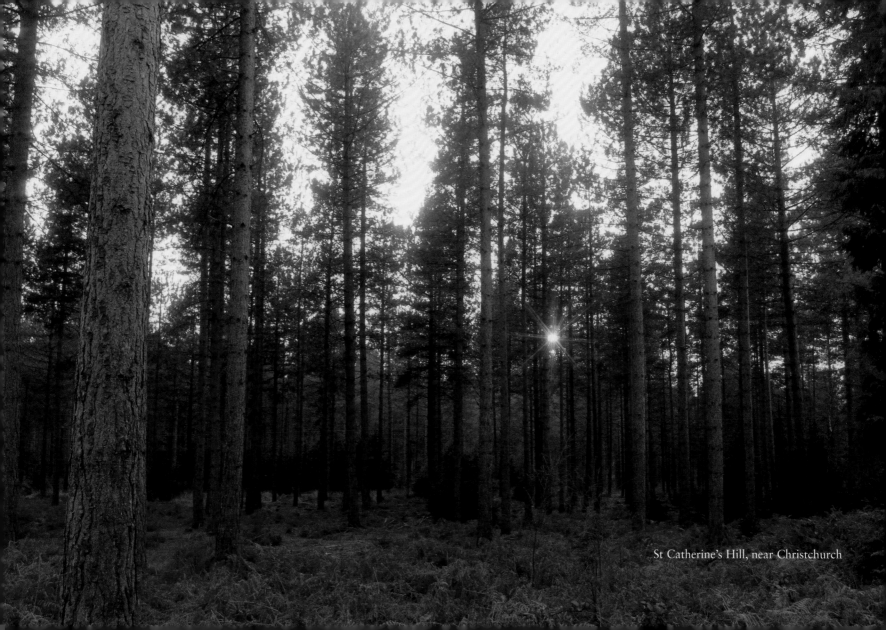

St Catherine's Hill, near Christchurch

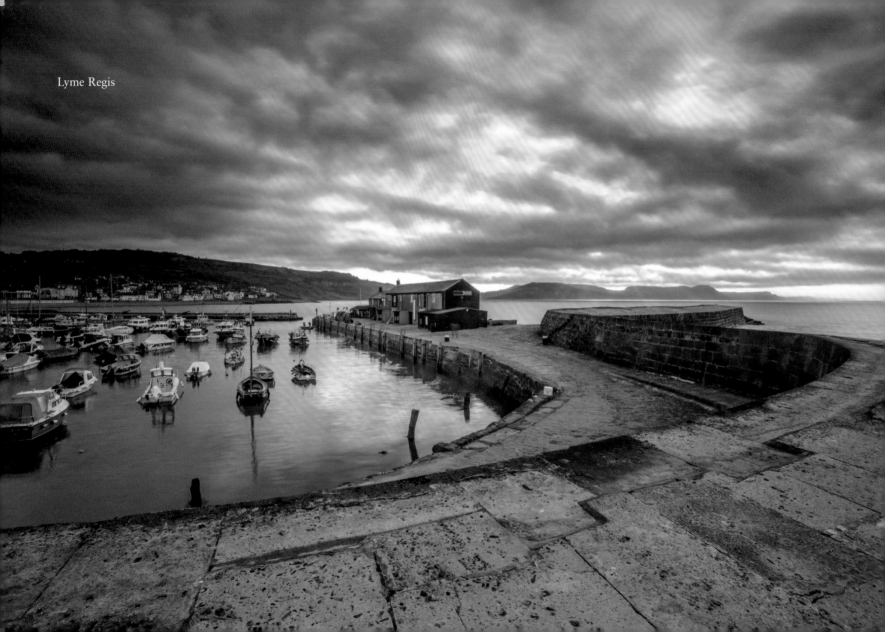

Lyme Regis

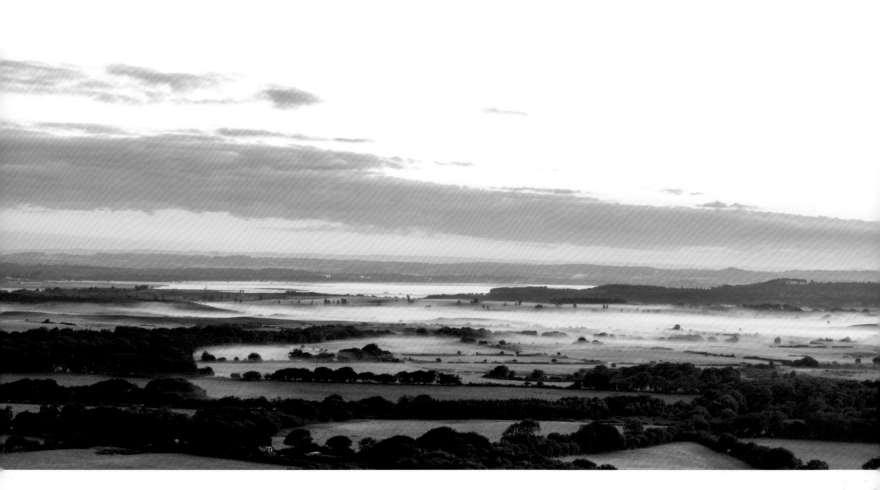

Misty field, near Wareham and Arne

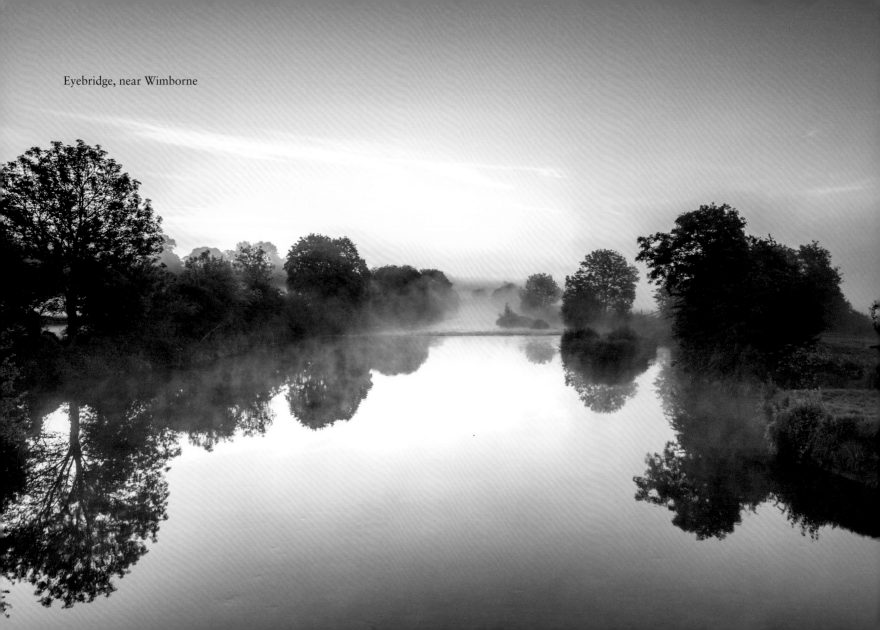
Eyebridge, near Wimborne

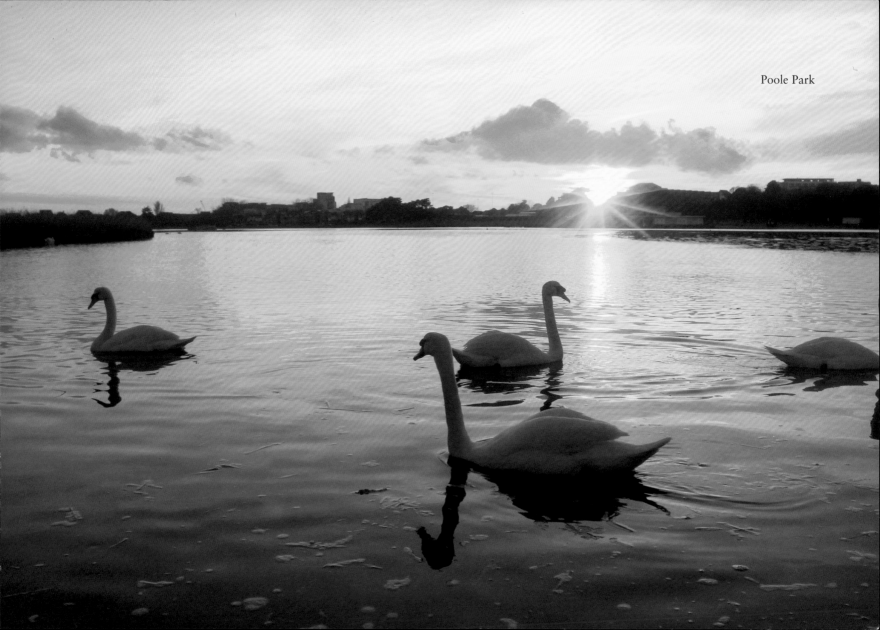

Poole Park

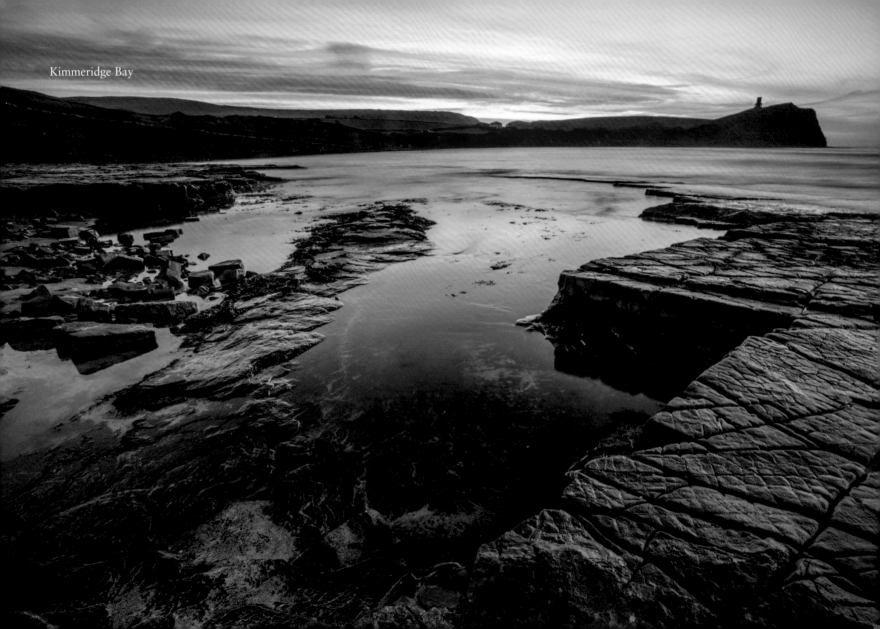

Kimmeridge Bay

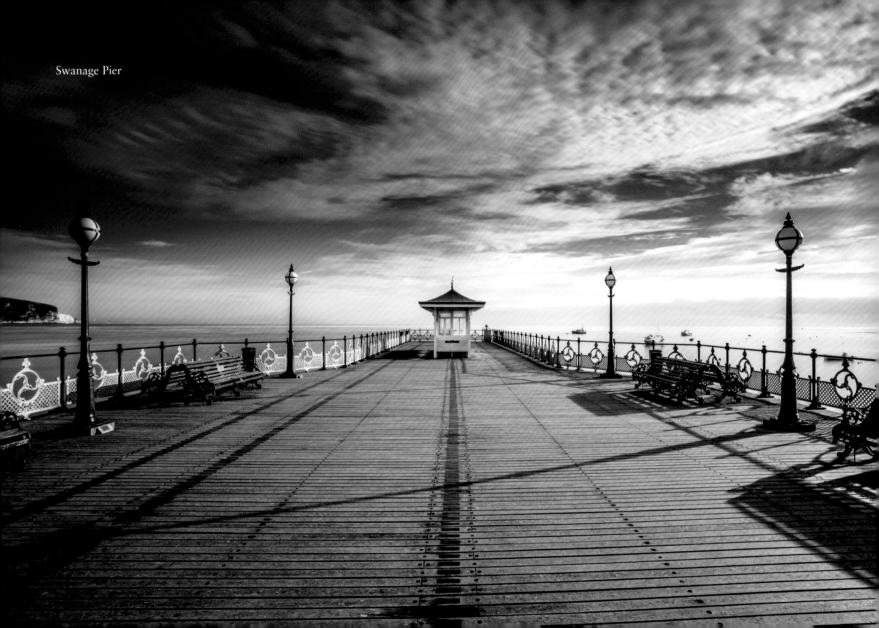

Swanage Pier

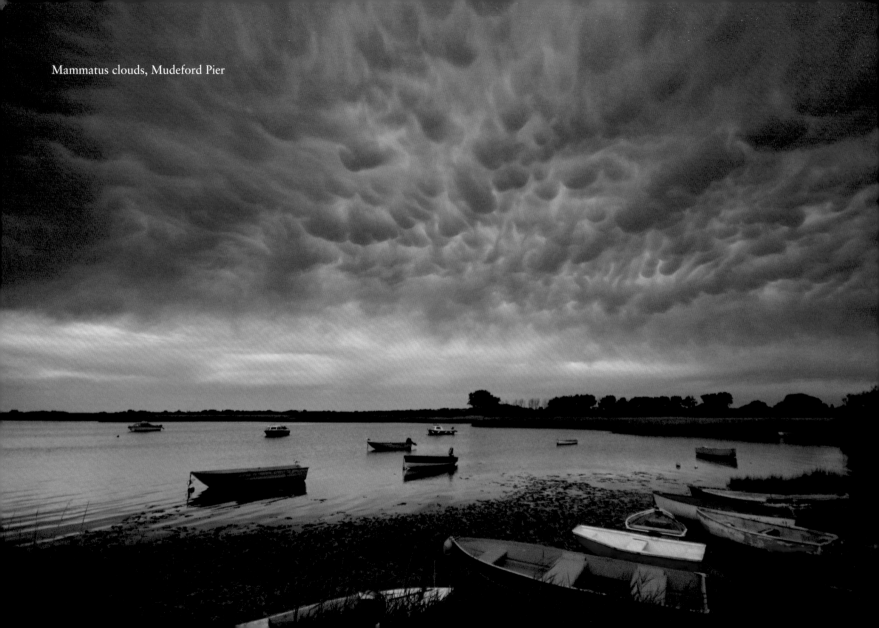

Mammatus clouds, Mudeford Pier

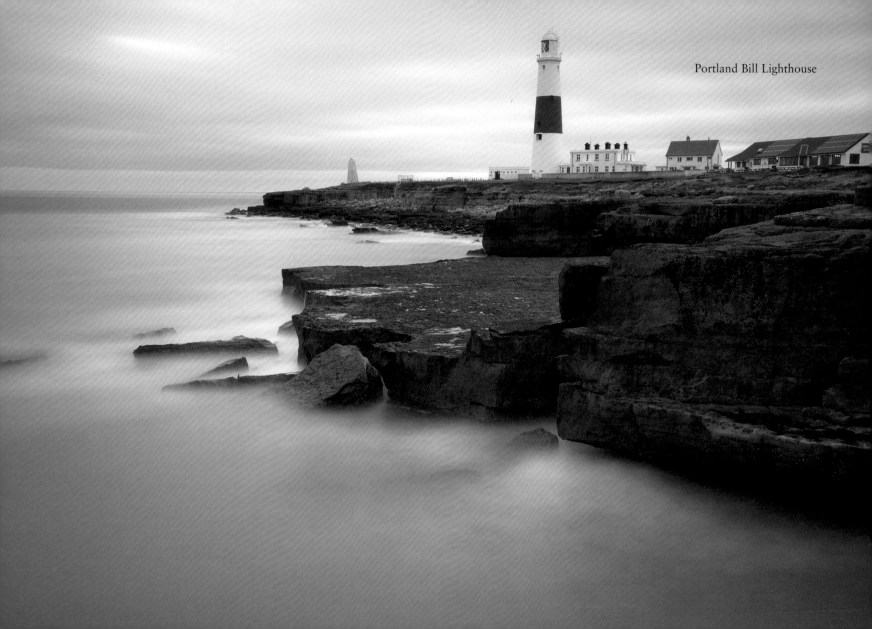

Portland Bill Lighthouse

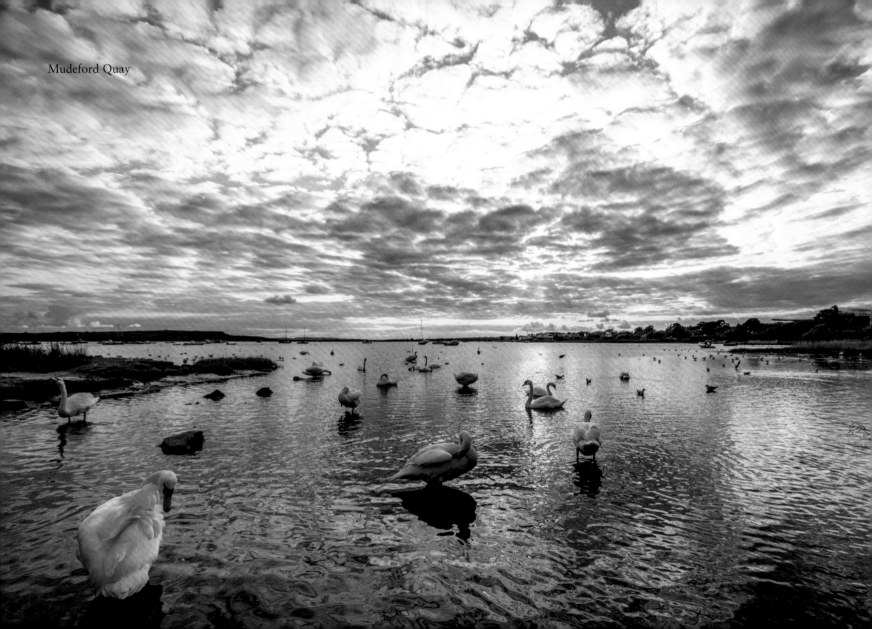

Mudeford Quay

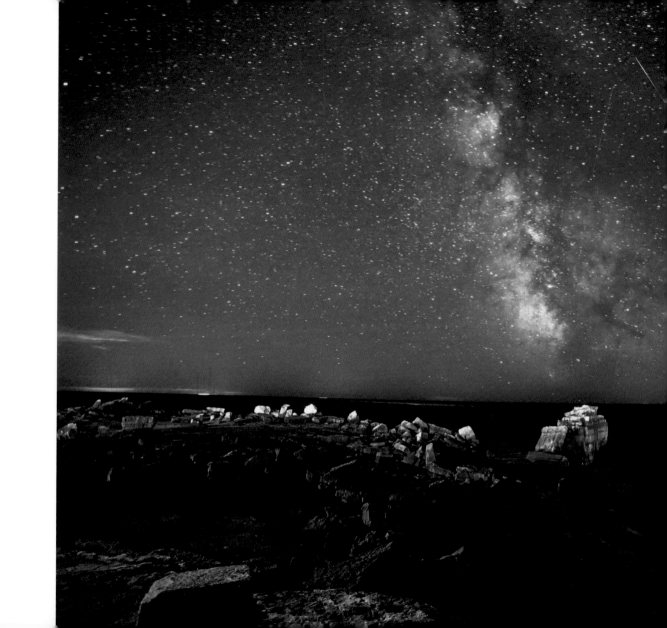

Pulpit Rock, Portland Bill

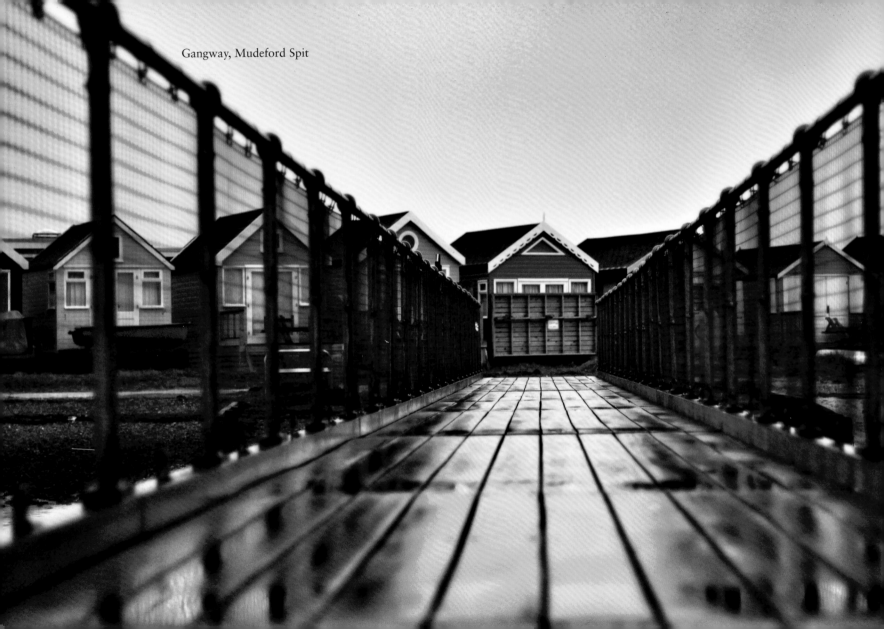

Gangway, Mudeford Spit

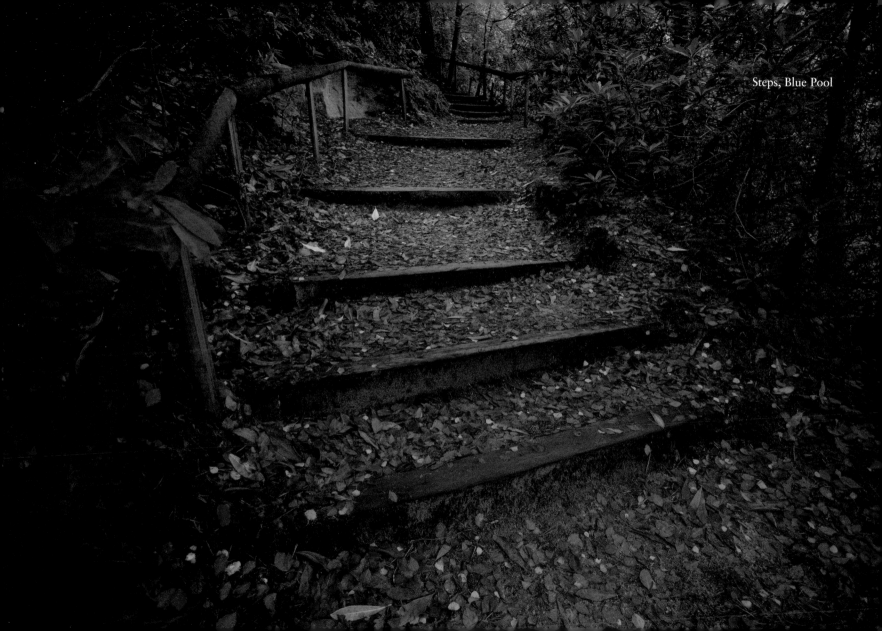

Steps, Blue Pool

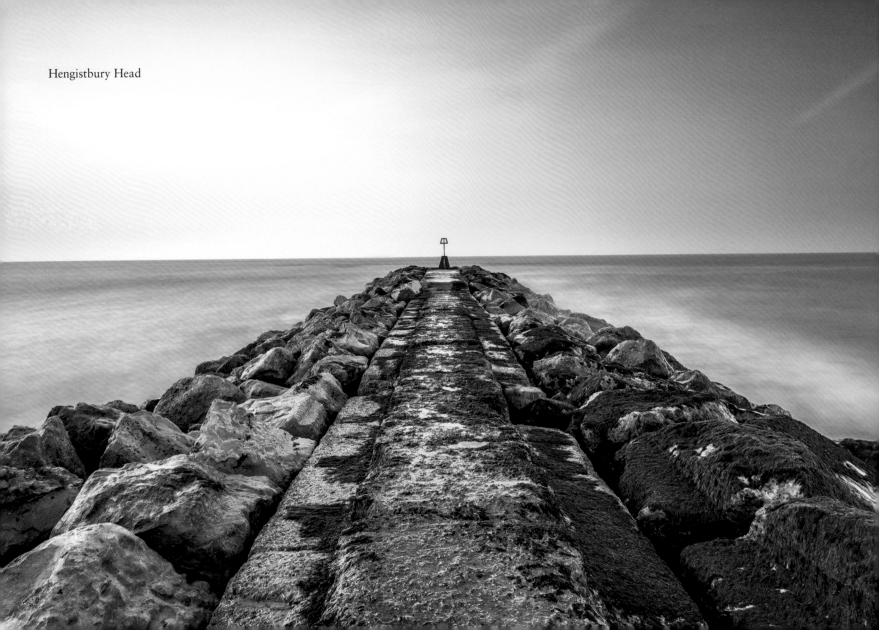

Hengistbury Head

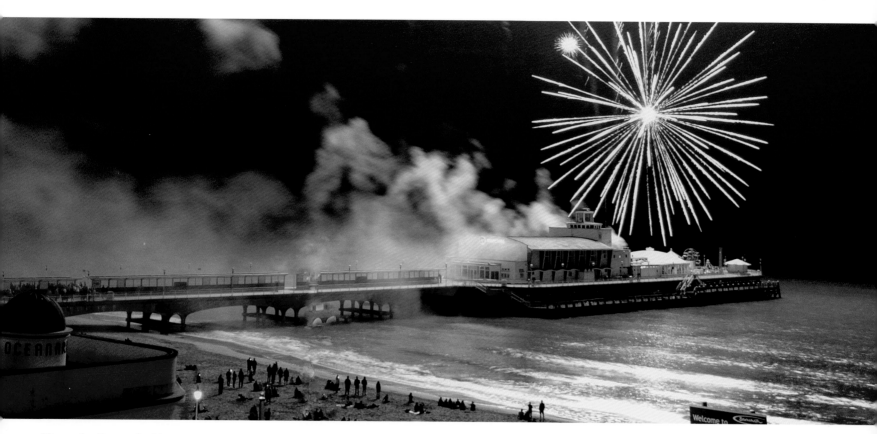

Fireworks, Boscombe Pier

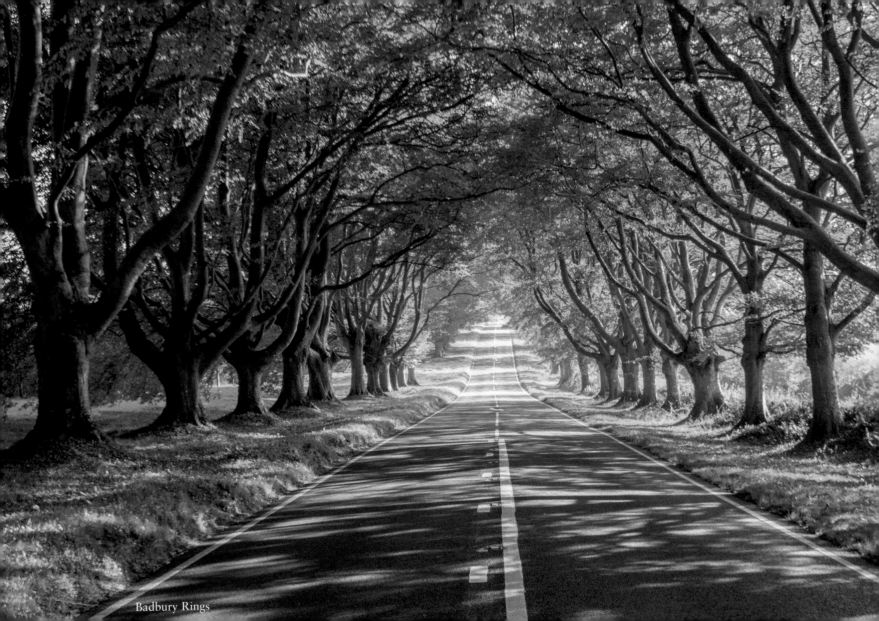

Badbury Rings

WINTER

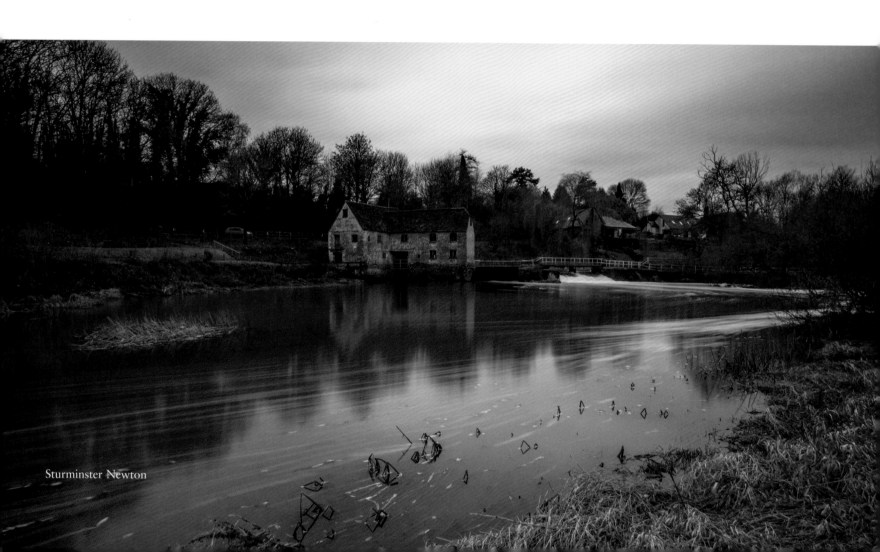

Sturminster Newton

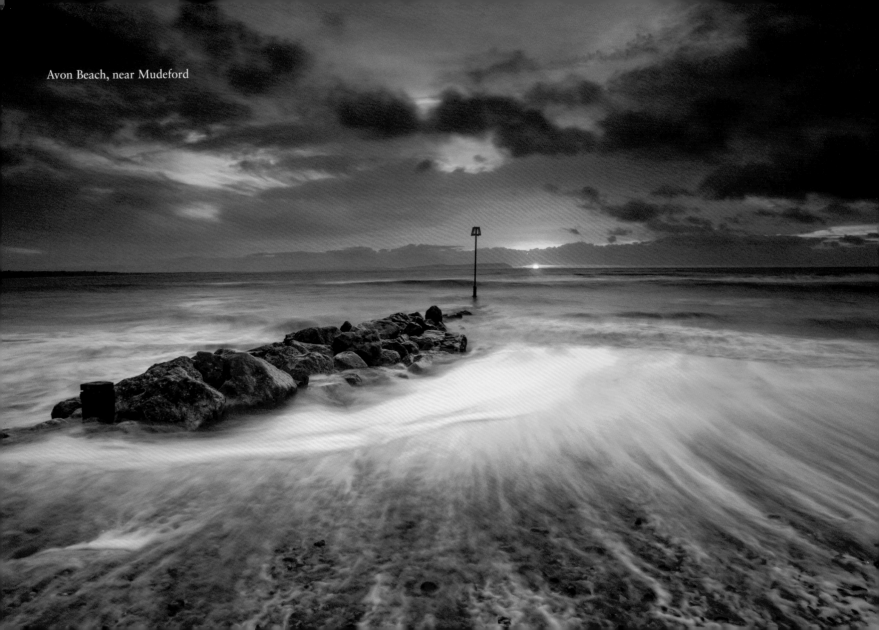
Avon Beach, near Mudeford

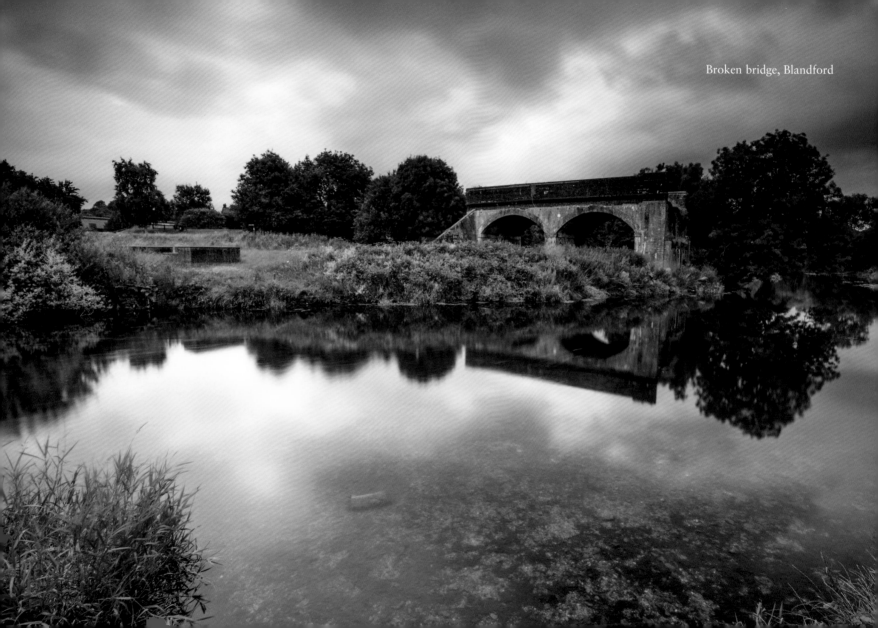

Broken bridge, Blandford

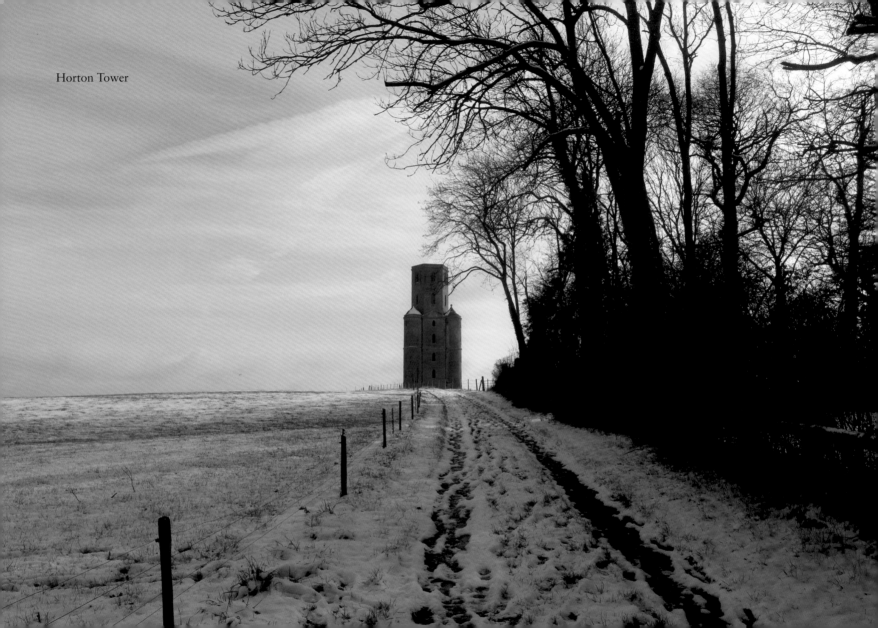

Horton Tower

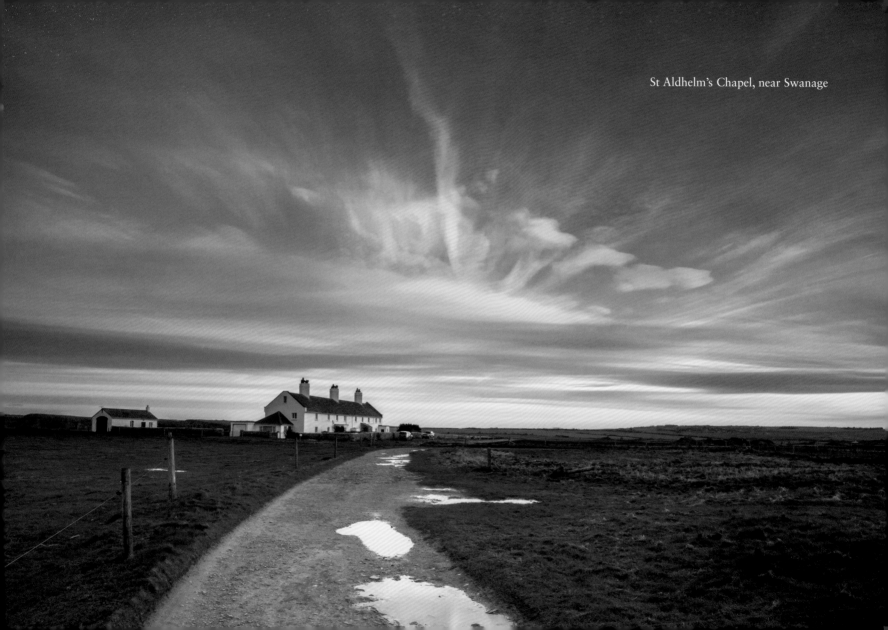

St Aldhelm's Chapel, near Swanage

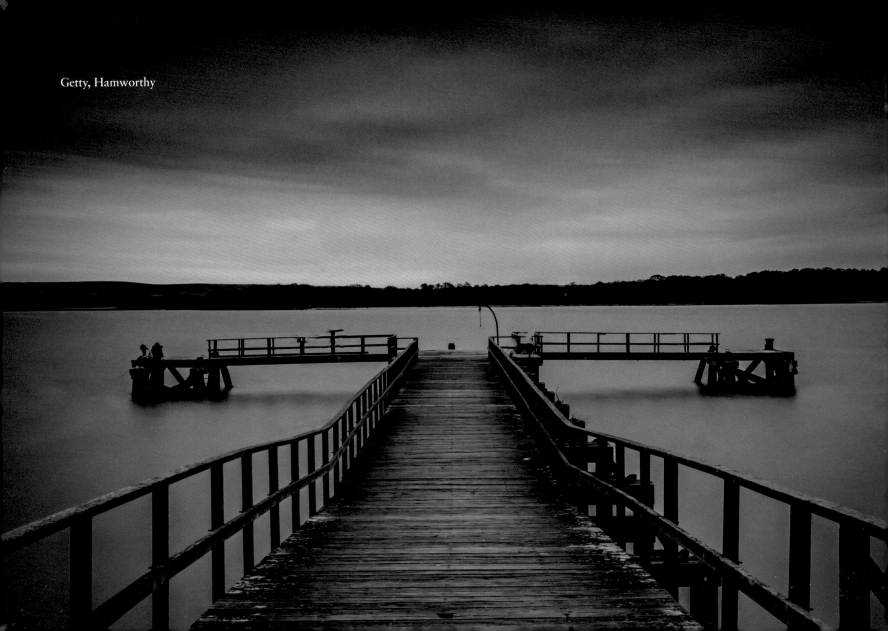

Getty, Hamworthy

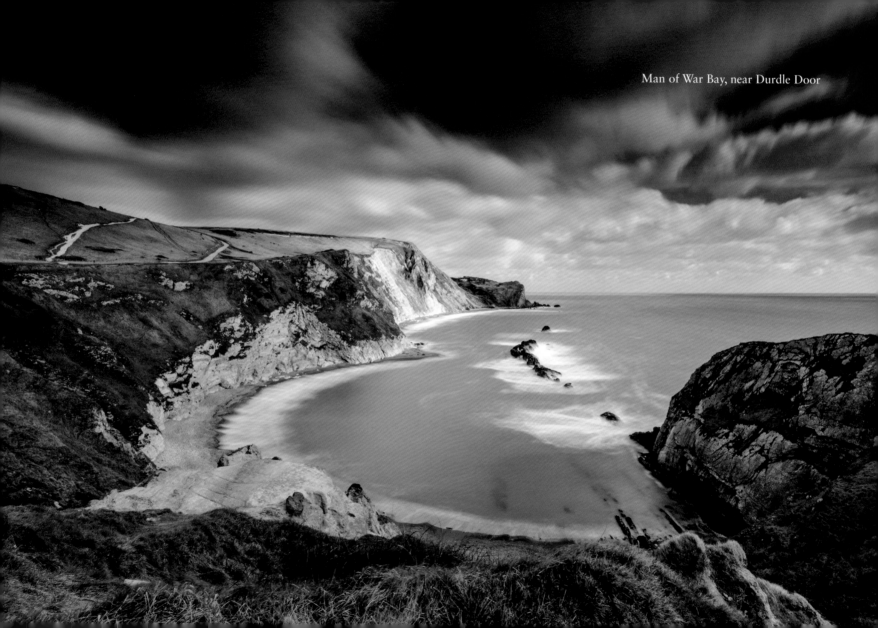

Man of War Bay, near Durdle Door

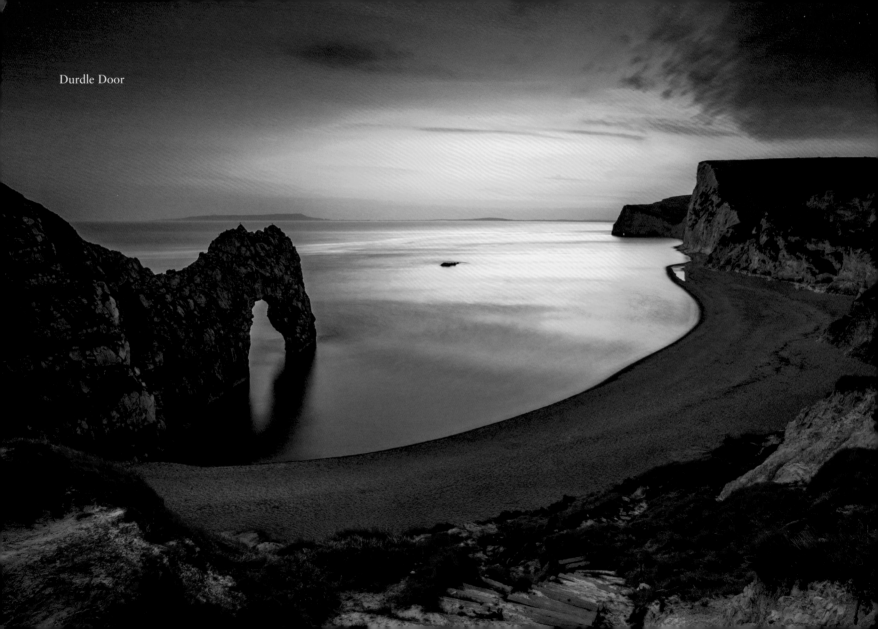

Durdle Door

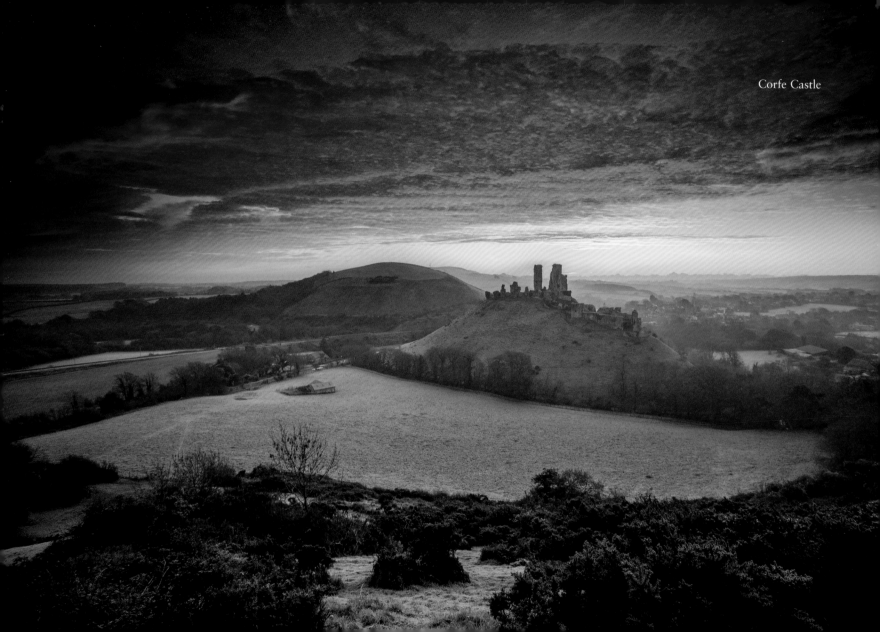

Corfe Castle

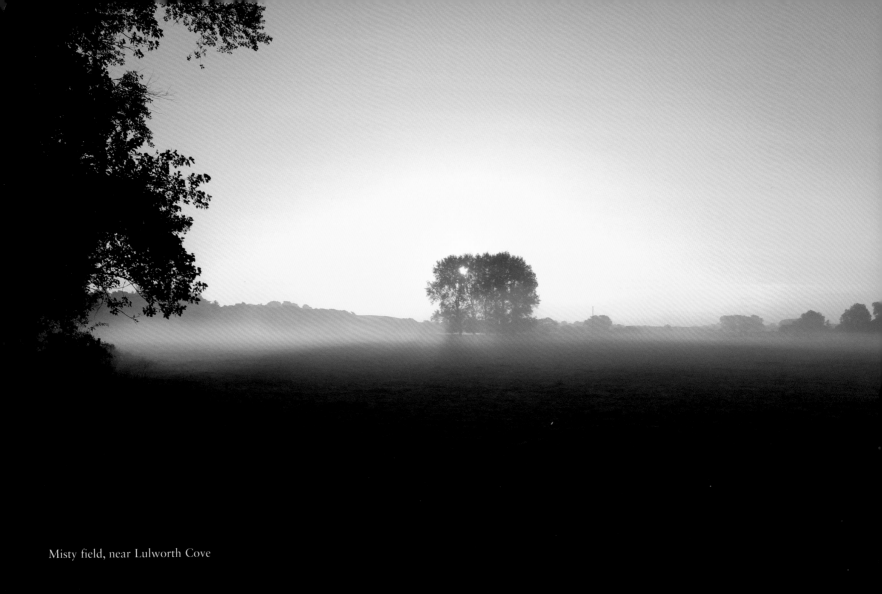

Misty field, near Lulworth Cove

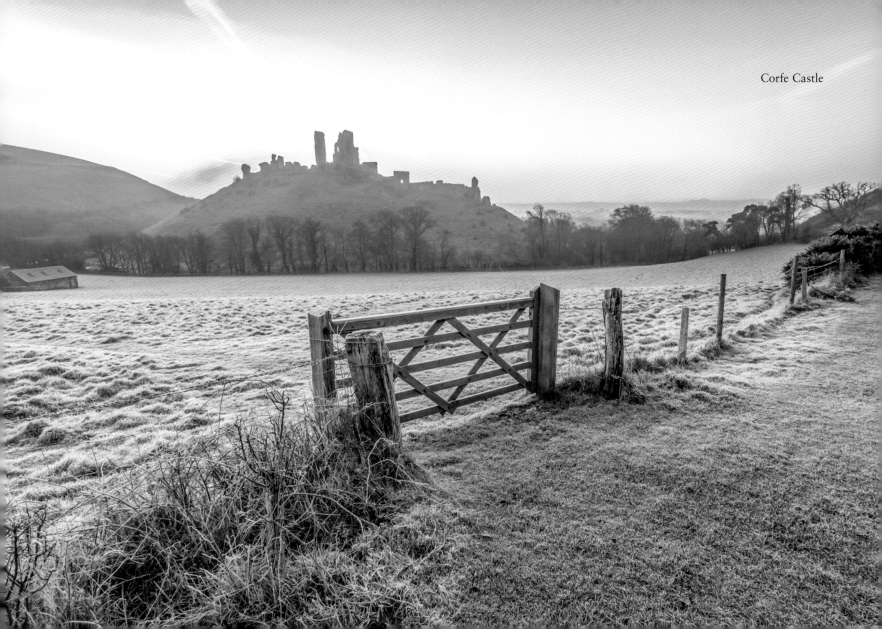

Corfe Castle

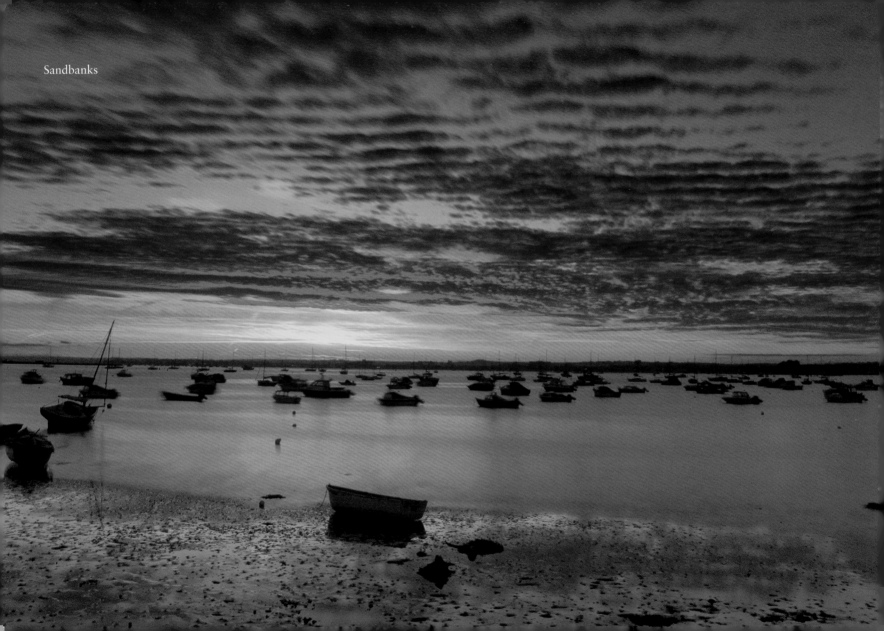

Sandbanks

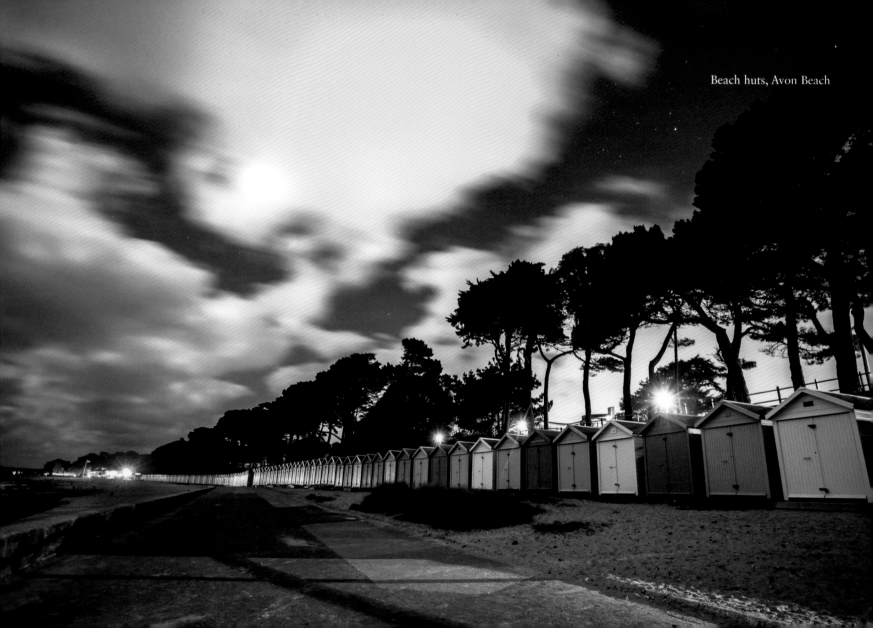

Beach huts, Avon Beach

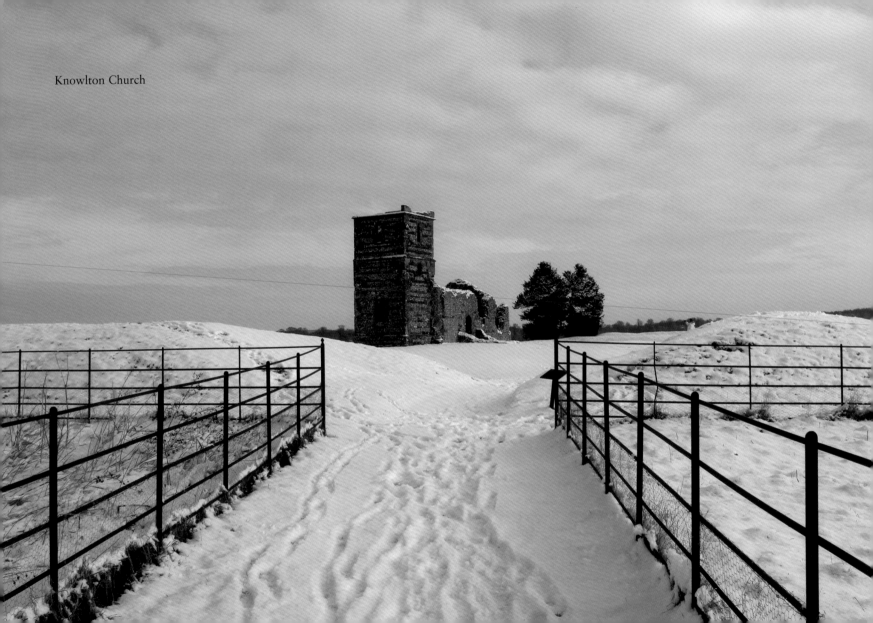

Knowlton Church

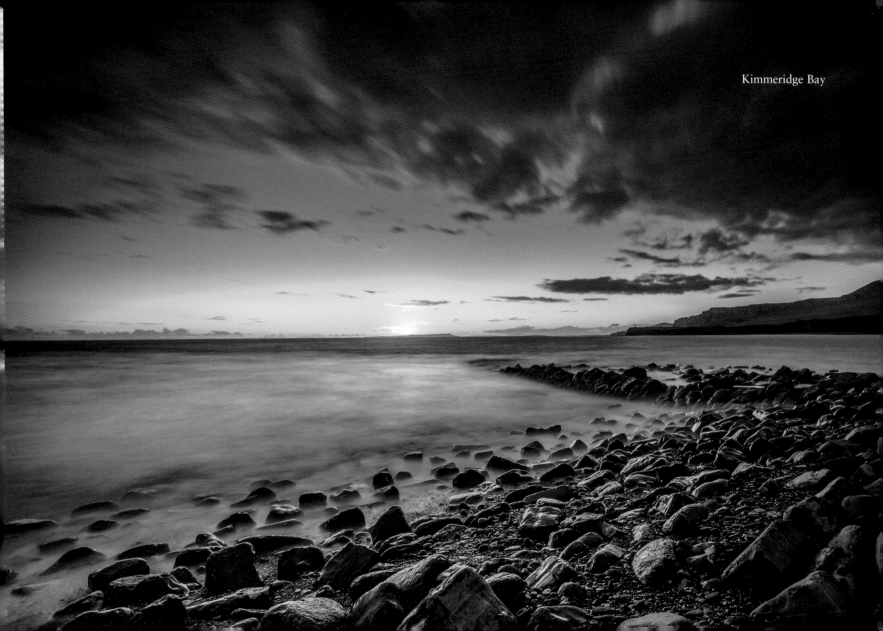

Kimmeridge Bay

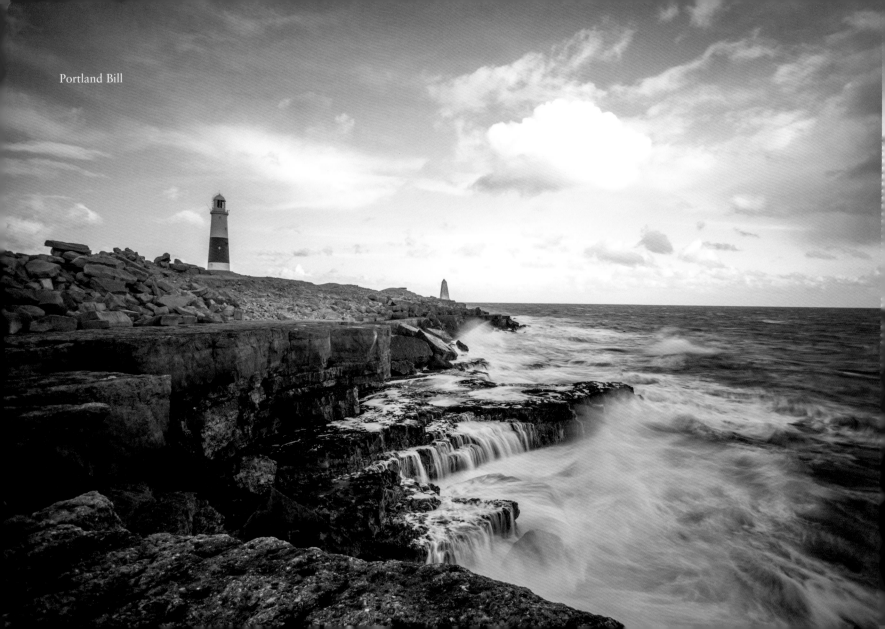

Portland Bill

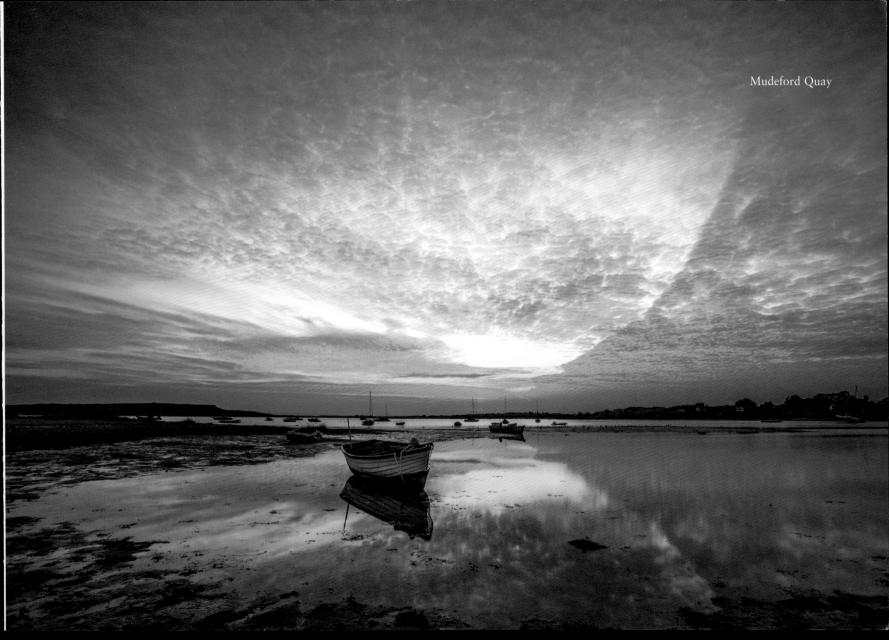

Mudeford Quay

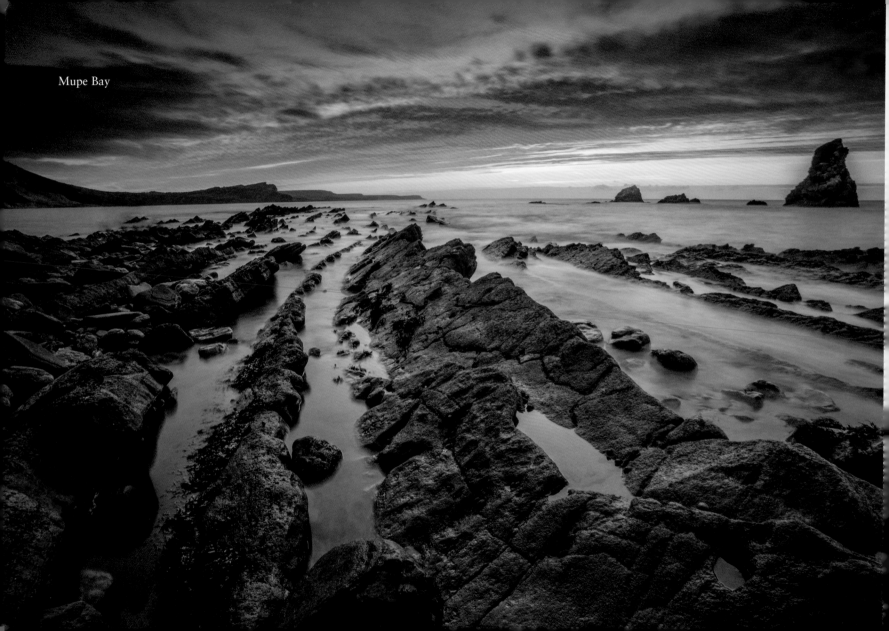

Mupe Bay

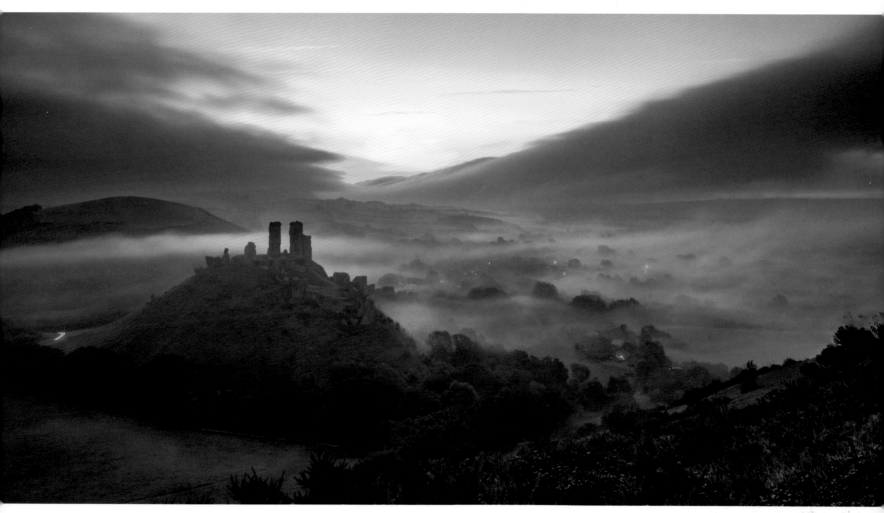

Corfe Castle

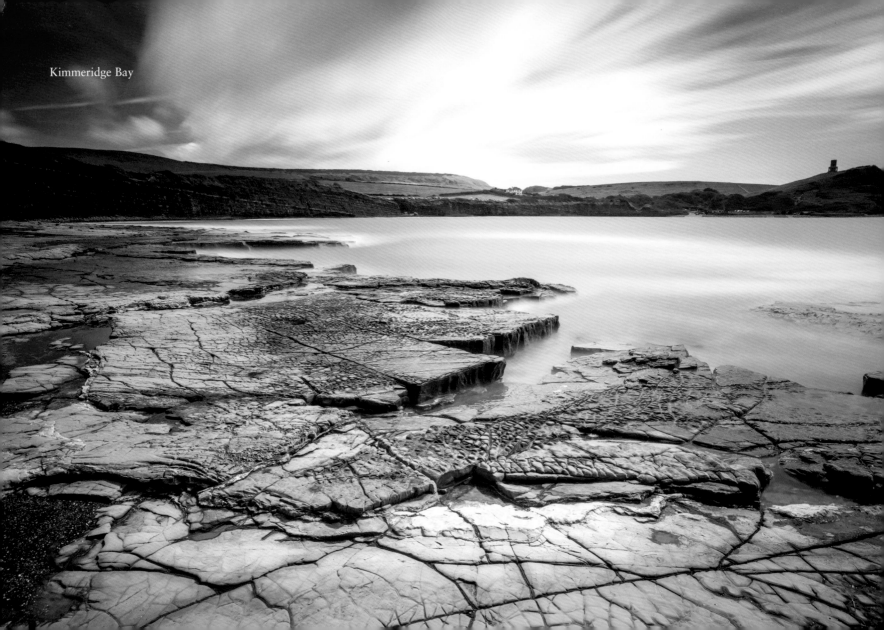

Kimmeridge Bay

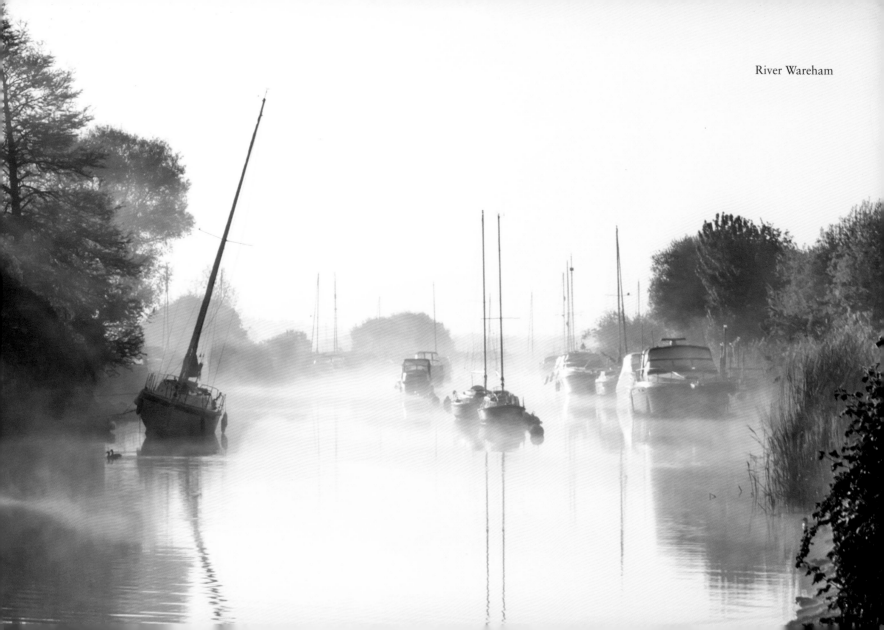

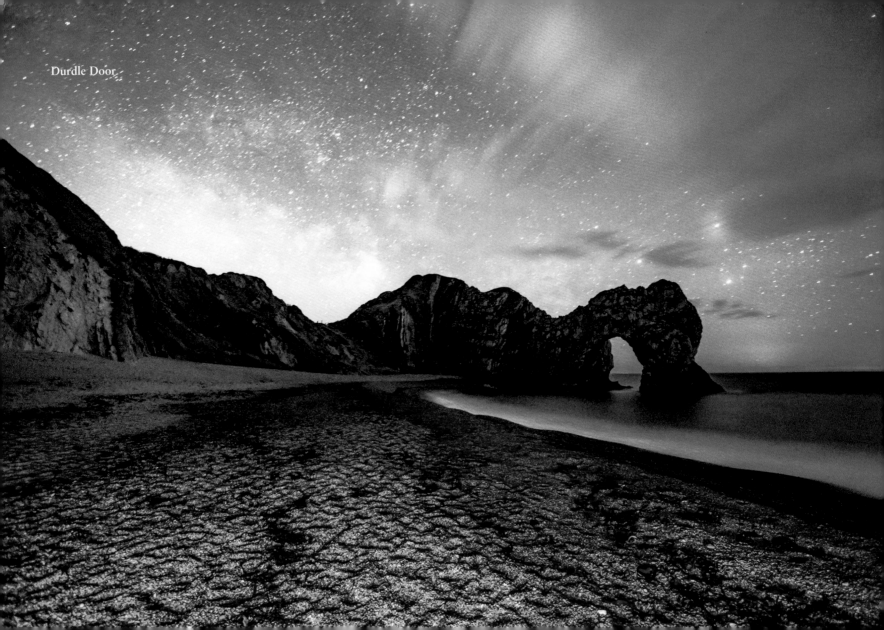

Durdle Door

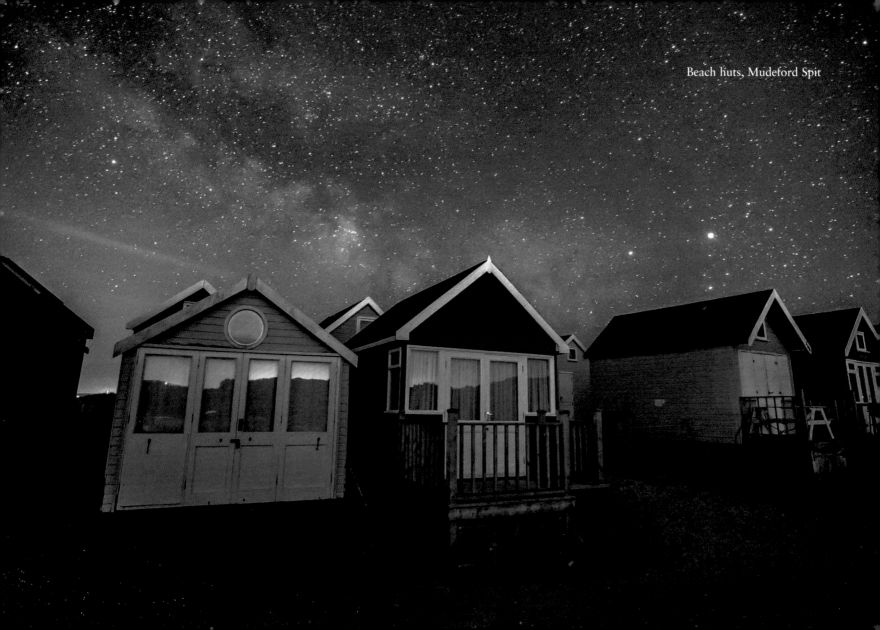

Beach huts, Mudeford Spit

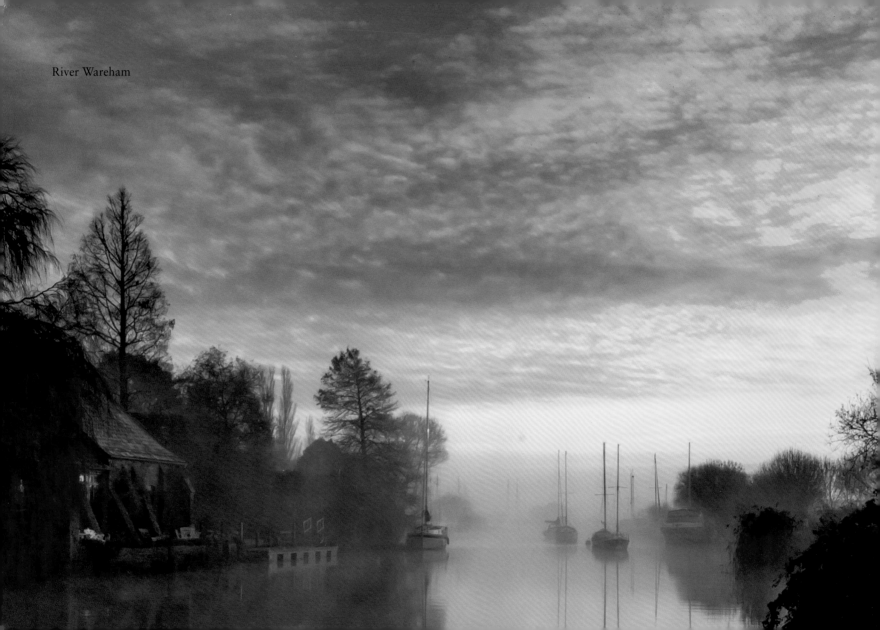
River Wareham